COLLABORATE WITH ZIO

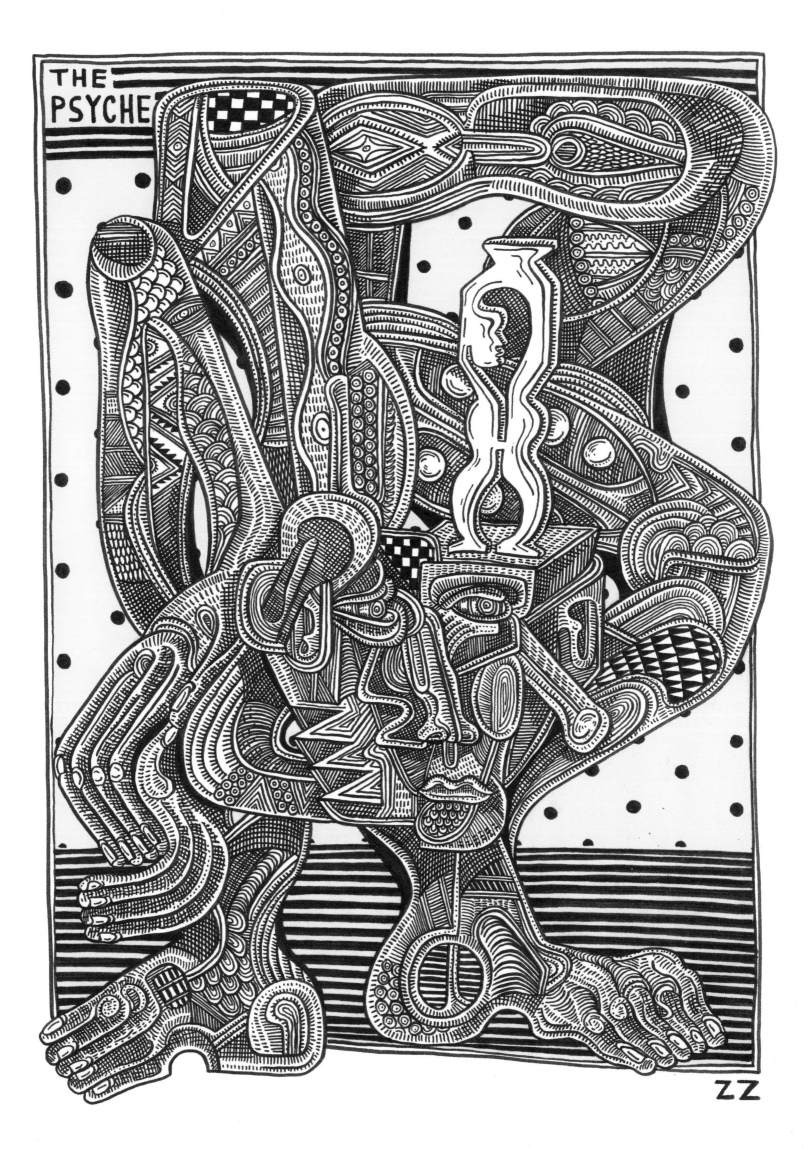

COLLABORATE WITH ZIO

THE ARTIST'S SKETCHPAD, COAUTHORED AND COLORED BY YOU

ZIO ZIEGLER

HARPER DESIGN

An Imprint of HarperCollinsPublishers

DEDICATED TO
VELIA, PATRICIA, MEL, AZA,
NICO, ROB, AND RUSS.

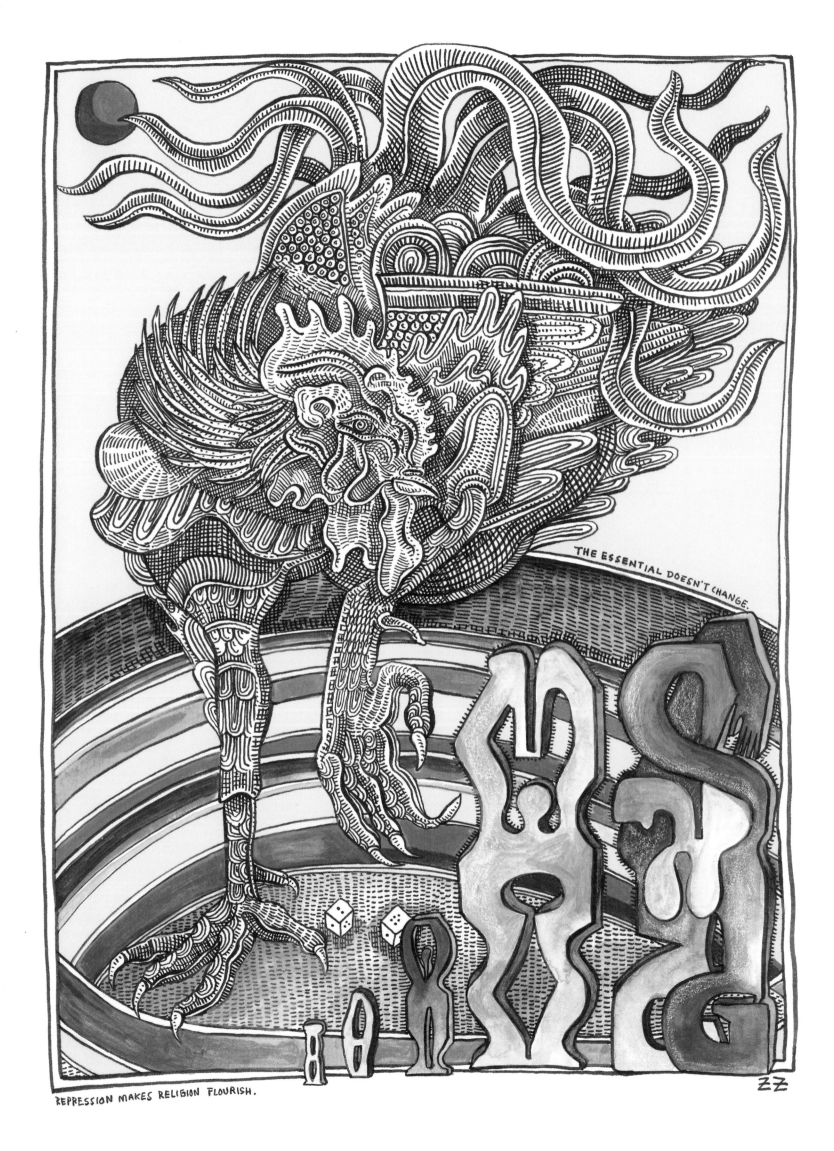

THE ESSENTIAL DOESN'T CHANGE.

REPRESSION MAKES RELIGION FLOURISH.

ZZ

INTRODUCTION

The goal of this book is to open the context of my work to you all. You are the coauthors, the collaborators, and the most important part of this process. It's your meaning that makes my work what it is, and your hand in finishing it that makes it yours, too. These images are open-source hieroglyphics: stories completed by you, the viewer. They are timeless narratives that exist because of your projections. It is my belief that every person has an equal capacity to create artwork. It is just a matter of nurturing your differences, putting time behind form and structure, and eventually watching what was once a foreign mark become your most clear form of communication. Many say, "I'm not an artist," but if you ask them if they have ever drawn, they reply yes. So why stop drawing? Why stop using this universal language because your pronunciation is not a standard one? It's our differences that make the art we make powerful.

For many years I couldn't draw. I would close my sketchpad when someone entered the room. I would only draw things that I "knew" how to draw, and eventually the more I shed the notion that what I draw has to look like something else, the more the floodgate of potential and ideas began to open. I could draw anything, but it was just *my* anything rather than the standard. And this is something I try to remind myself of every day while creating. I take away the consequences, the judgment, the inhibitions, and doubts, and I just trust my hand and mind and let the image form. If this book can do anything for you, it can reinforce the truth that your marks, as different or unpracticed as they are, are just as valid as those of your favorite artist, because in my opinion art should reflect the soul, not the standardized opinion. So enjoy this collaboration!

I hardly ever sketch for my murals; rather, I draw new forms and figures to test ideas while I am en route. The images come from the subconscious, and fit together on the page based on the flow of the drawing. Nothing is premeditated, but creation can be prompted by myriad inspirations.

Often my challenge in creating drawings is how much impact my self-consciousness plays in their rendering. I'll be halfway through an intuitive image and then realize I don't know "how" to draw it. This tension between knowing and trusting creates works that are redundant, and frightened, works that stay in their comfort zone. In order to break out of this comfort zone, I have to draw from necessity. I draw because I have to clear my head, or I have to understand a life issue or problem that has presented itself. Drawing becomes this process of resolving life's metaphysical problems. And when you are creating from that need, it's got nothing to do with knowing how to draw or how not to draw, and everything to do with just putting pen to paper and trusting your hand.

You'll see motifs in my work that repeat themselves in hieratic scale. Their sequencing and serial nature are important because many of the drawings are meant to be read like a song: open to interpretation, the tones and lyrics just guiding principles that allow you to look within yourself or at the world in a new way. The emphasis of one motif, or the building toward it, is like a spherical song, or an environment that after being examined redefines itself based on the viewer's potential for many perspectives.

I have never had a chance to be anything besides an artist, and trust me, I have tried. I've pulled myself toward many other careers out of fear, because I just didn't know if I had something to add to this vast heritage of painting. Because the more I painted, the more

I really tried something different, the more the institution told me I was terrible at it. And so I started to redefine what it meant to be an artist for myself. I was not going to stop because they told me to, I was not going to conform to what it meant to them to be an artist, and I most certainly was not going to follow the path they told me to, and so art became a device to communicate with an audience larger than the "art world." It transformed into something that had to be bigger than its context. Something with a magnetic force for me, which pulled me into its submission. Something that stands in for your self-worth, something that you live through. Something where you cannot hedge your bets or go halfway. Once you know that you need it, it owns you, and your life becomes a series of trials in marrying art and reality.

Often things that are ahead of their time cannot be understood in their time. People see the future they want to—they see their own self-interest and their own projections—but art sometimes shows them a future that has no regard for time. Great art seems to survive outside the movements and realities we create for it. It organically finds a resonance with those willing to see it.

I think it is of the utmost importance for art to be in the streets. Many young people can be scared of the attitude of museums and of galleries, and they feel as though they must know something in order to appreciate art, but on the streets it is completely democratic and completely equalized. Art in the public space makes the public think, because there is no wall text from curators, and no institution saying it is or is not art; it is the eye of the public that decides. And often they vote for the validity of art by taking a picture, or by engaging with the work in some way. This keeps art alive and fresh, open to people's ideas rather than behind velvet ropes in a white box.

Street art is monitored by the public; its destruction can be mitigated or brought about by anyone with will power or a spray can. These pieces can become treasures that shine in contrast to the rest of the advertising and cohesion that the commercial world presents us with. Treasures that the people can feel spirit and soul in, and therefore sometimes protect as mirrors to their own individualism.

OPEN-SOURCE HIEROGLYPHICS

In today's reductive culture, the idea of the infinite is slowly collapsing. The word is no longer the bond. The frontier is "known." Language no longer contains the linearity and meaning that we once blessed it with. We exist within concentric rings of contradiction, while ignoring the labyrinth in whose nexus we sit. Search engines provide direct answers rather than proposing the context of the answer we seek through the discovery of its original text. The path that was once the goal is now becoming a systemized device that delivers us from A to B as quickly as possible. Efficiency was once ease, and now promises to be the death of creativity.

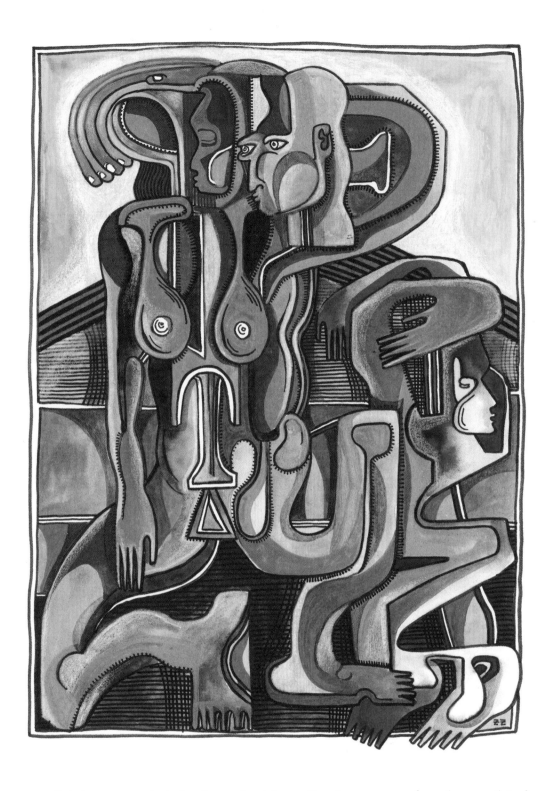

Paintings are made in tension and resistance. True images come from the gauntlet of translation from mind to physicality, and from hand to canvas. What contorts our initial instinct, the errors one encounters along the way, the imperfections that exist outside the mental vacuum, are what defines the work; one could say that the underdog flourishes from his eccentricities. What allows someone to initially exist outside normality, the stutter of Claudius or the illness of Proust, is what gives one the freedom to live in a vacuum, in an infinite of our own, and allows us to hone the ability to translate the very same infinite through ourselves. The individual who is rejected is not softened by the banalities of society, but rather sharpened by the system's rejection. And so, in differentness, in individualism,

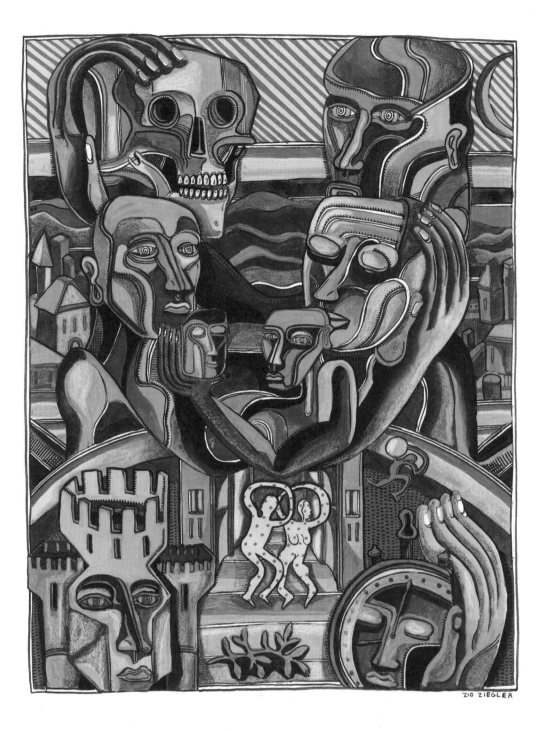

man turns human bondage into his unique catalyst for freedom much as a mountain range presents a challenge for the river that wears it down throughout time, creating its unique character. Difference plus willpower form unique habit. A habit honed without the support of society is individual enough to persevere in the face of acceptance, for it is not acceptance that has defined it.

Challenges are what define us. The wandering from A to B, the creation of one's own path is what creates the conduit to the infinite. Like rivers, we all need to confront mountain ranges. Of course, the river must run for long enough to build up its momentum to push through rock. The longer one avoids compromise, the easier it becomes to embrace the alienation that is inherent to the human condition. And so, taking in the resistance, as the wet stone that sharpens the blade of individualism, one must find the rhythm between ease and tension.

An artist needs to relish the iambic pentameter of duality in order to shape the images that translate his mind's vision to the world. Within this adversity, this alienation, lies the commonality of the human condition, the inverted search engine, the ladder that one cannot ascend until one casts it away. When reversing efficiency, we climb back along the parabola of human achievement—from the efficient, through the answers themselves, then through the questions, eventually passing into the unknown. Then we enter the questions behind the questions, the motivations behind nature in giving us an infinite that our society in its confusion has inverted.

For this vacuum is not a pie that can be divided, or an unknown that can be known. It is a world in and of itself. It is only a step away but it cannot be approached by the logical mind. It is so omnipotent that one must exist without the ego, without the self, and without the necessity of "I" in order to enter it. And even without "I," it cannot be seen because it is true difference itself. It is the state between two states, the glue that holds yin and yang together. It is the ether. It is the sun that you cannot look into, the light that cannot be captured, and the question that cannot be phrased. It requires all of human literature and painting and creativity to testify to its ineffability.

Our tendency is to collapse this unknown into smaller and smaller unknowns, until unknowns are just bite-size pieces, concepts divorced from their contradiction. They change and tire with invention and time as we chase the quantifiable infinite we choose to see, ignoring the vacuum that we cannot comprehend.

And so I say, reverse this system of efficiency into one that brings us closer to these unknowns. Journey back toward analog. Break the systems that hold our minds to principles that satiate economic needs rather than human necessity. Fly too close to the sun to experience this unknown for yourself. Daring individuals have set the pace of human achievement. They cast away the concepts and mercenaries of pseudo-erudition with their canvases on the floor and their anti-aesthetic images, and embrace that which cannot be spoken. It is tension that pushes humanity toward creativity. The ebb and flow of belief and will that battle toward this infinite data point. The willpower that created gods on Olympus and paintings in cathedrals, the willpower that found images and narratives to be the closest approximations to the collective unknowns.

Theses images were the first attempts of language to transcend time and culture and embrace that which cannot be spoken—the sanctity of the unknown, the discomfort of that which stands alone. For all which runs again the norm becomes the anti, until the organism of society's norm nibbles and gradually consumes and assimilates to that idea.

Let us create art for art's sake, rather than art for art history's sake. Let us return to the hieroglyph, without the deity, but rather with a new infinite within ourselves. Let us witness the transience of concepts, and the timelessness of art made from the human condition. Let us make the infinite open-source. Let us turn the unknown into a device that generates more unknowns—a spark to light tomorrow night's fire. Let us push back past when man

"AN ARTIST MUST BEGIN BY CUTTING OUT HIS TONGUE."

—Henri Matisse

worshipped a god that his ancestors named and created. It is within the human tradition, and within the human condition, to make the world as understood as possible, and to let the arrogance of the understanding become our demise. With time everything becomes relative and in its relativity becomes reductive. Be he hedgehog or fox, today's man cannot escape the fact that his efficiency has burned his bridge to the unknown; his "knowns" and acceptance of "facts" have destroyed his ability to wonder and evolve. Let these open-source hieroglyphics serve as a scion of the unknown, as temples within which to wonder again, as sparks to rekindle imagination, or mirrors for self-examination. Let these narratives, which only come through me as I once passed through the mountain, come through you in their inversion of your usual searching. Let them be more expansive than your first glance found them to be. Let them be as organic as the ideas they germinate within you.

For these images are the catalysts of your thought, as I was simply the catalyst of their creation. The subconscious, the unknown, must exist without definition in order to be the unknown that we desire knowing. The Tao that can be spoken is not the real Tao. Let these paintings lead you to understanding.

The world functions from equal and opposite swings of the pendulum. It is time to embrace the unknown again, to search instinctually toward the resistance, the adversity that hones individualism. We must embrace all facets of our character, our Ahab, our Queequeg, and our Ishmael, in order to enter the infinite. For the ladder we've been climbing must be cast away in order to ascend it.

This piece (*opposite*) shows the paradigm shift that took place in my work from a sculptural pattern figure to a more amorphous future. The juxtaposition between the two figures represents the constant dialectic that takes place within progress. Staggering from one known to one unknown, the work zigzags forward, finding its evolution through the duality of its mark making. These paintings pay homage to myriad textiles and cultures around the world, showing not only the globalized nature of the creative culture today, but also how easily one can access histories and images, which in previous centuries required pilgrimages. This ease builds a sort of bovarism that lets my hand turn flesh into pattern, and pattern into figure. These are supposed to represent aggregated monuments, or fractals of influences buried into one body. The raw and painterly figure stands by it side attempting to hold it, as a symbol of the innate thirst for progress and surface that did not exist in the aforementioned figure. These two allegorical bodies hold a moment of tension between habit and novelty and represent curiosity and deconstruction I hope to pursue in this project.

I find inspiration primarily in literature. I listen to audiobooks while painting, and in many ways literature forms a context and motivation for my studio work. It can be anything from art theory to Roman history, but the more complex the better, as it allows me to move my mind from my painting and enter an ethereal space, and mirrors impulse and desire as the justification for work itself. Visually, I find inspiration from a lot of primitive and outsider art.

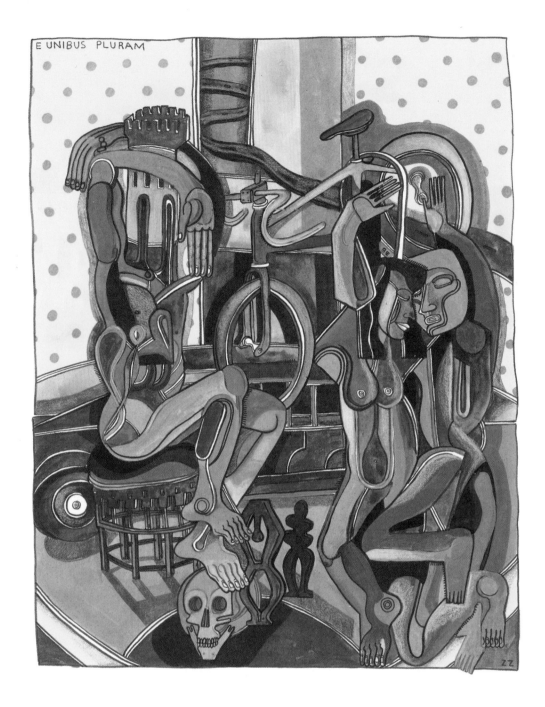

From hand-painted signs to early cave paintings—I'm interested in art that was not aware of its own title during its creation; in other words, art from necessity, or as a means to grander communication. I am as interested in the visual language of comics and cultural symbols as I used to be, and now find inspiration to be within art objects that spoke to those not trained in art, that motivated culture toward a paradigm shift—or art that answered the questions of the infinite. Inspiration can also be found within nature, and the abandon of ego in the wild. I ride my mountain bike every day that I am in the studio, and it strips down all the worry and relativity one can find in today's world and reduces you to a smaller piece of a larger spectrum. You're reminded of how important it is to be adaptive to the unknown path ahead, how it's not the stone or tree a quarter mile down the road, but the one right in front of you. It is a phenomenal exercise in humility and mindfulness, and when I reenter the studio later in the day, I am able to view and create from a much more grounded place.

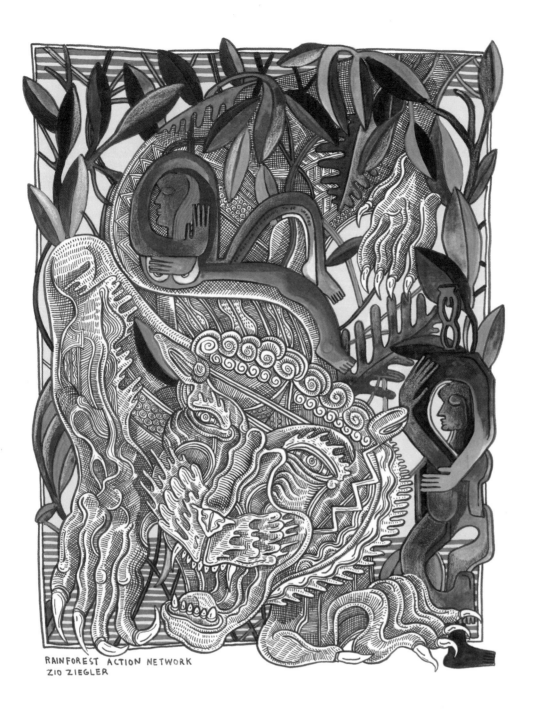

RAINFOREST ACTION NETWORK
ZIO ZIEGLER

MY TYPICAL DAILY ROUTINE

I wake up early. I drink coffee and eat toast with almond butter or a breakfast burrito. I procrastinate emailing people. I paint, then I email. I begin new projects and abandon others, struggle with surfaces and finish paintings. Then comes lunch, which means burritos. Then back to the studio, where I work all afternoon on paintings, and leave around five thirty for a bike ride. I ride for two or three hours, and then grab food and come back to the studio and work until my eyes can no longer stay open. When I travel it's pretty much the same, except adding in flights and turning the canvas into a wall, and the Mexican food into whatever is the local cuisine. I don't believe in taking a day off, a day away from work, since I don't want to lose the momentum or train of thought that occupied my hand before. So even when I cannot paint, I still try—and that is the hardest but often the most rewarding. As you no doubt can tell, I am a bit obsessed, but I would not have it any other way.

Our faith is a visual one. Because we can "know" anything we want, the value is no longer in knowing, but in what we don't know. It's taboo to speak against something that everyone says has value and that the world pays for. In a similar way to the gold standard, and the standard of language, we must all agree to get along. We must all compromise in some way to exist together.

THE PSYCHE'S GESTURES

With the capacity to easily generate an image, and a truth with that image, the value of an image slowly fades and in turn so does the truth.

We are defined by our struggles, yet somehow avoid them at any cost because patience is no longer economically viable for the pace of the world. We see art objects that are anti-aesthetic, making the entry barrier simply the ability to transcend the mass visual and enter into a more cerebral engagement with the work. To use an apt cliché, we can no longer judge books by their covers because the covers are either so numerous, or so consciously anti-aesthetic, that they evade engagement by camouflaging themselves against those interested only in surface. But say all artists were to follow these queries of "innovation," each trying to find a way to reduce the process of painting to a new way of anti–image making rather than playing in its vast history of aesthetics, and the work became so detached from beauty that it was reliant on its context. What happens when we are no longer there to provide the context? When those curators are long gone, and the common person mistakes what was once valuable for a piece of trash? Do we follow the curators' choices from the past or that of the populace, and are the two mutually exclusive if one must always be elevated from the other? The reliance of the anti-aesthetic work on the institution leaves art for art's sake far behind, and simulates an environment where art is purposely getting as far from what we "know" to be art as possible. Yet Duchamp's piece without a signature is simply a toilet, and an Art object without a Museum is simply a testimony to the fulfillment of a society's hierarchy of needs, art as artifact—as a reach for posterity from the people. But how can art affect humanity, if humanity cannot recognize it as such?

With the commodification of artifact comes a culture's iterations and dialogues, or context-heavy emphasis rather than that of art that transcends its environment. But if an image is no longer representative of the truth, rather than the truth we want it to be, isn't it more necessary for art to be an articulation of a truth we all must acknowledge, that of the human condition? There must be tiers of inaccessibility for desire to be present within art, but it seems as though the market is trying to fabricate history faster than we live it, instead of focusing on that which will have an impact for posterity, and without its context. If we can learn any lesson from the curation of history and the selectivity of memory, it's that art

"BAUDOLINO HAD NEVER SEEN THE
CREATION OF A CITY, ONLY THE DECLINE OF ONE."

—Umberto Eco

objects survive out of their emotional impact rather than their projected economic value. If art is a vehicle to speak a larger "truth" to the soul in the era of the destabilization of reality, then why choose objects that further distort our notion of truth?

The survival mechanism of soul in some art comes from a knowledge of aesthetic principles and a connection to an emotional source melded into an image that evokes feeling, and from feeling, thought about feeling. We must feel to remember, and to make a society that is so used to images feel again, through the catalyst of an image. The images must have an emotional truth to share as well as an intellectual one. How can art mirror culture, or be responsible for mirroring culture, if culture is nothing more than a series of reflections from one mirror to the next? Culture today is a series of economic and intellectual entry barriers, "truths" perpetrated by those with an interest in holding the mirrors, and is only able to generate more and more fractured and iterative products.

We stay within this prism of images and dialogue because to leave it means to engage head-on with larger, ineffable truths, and because we live in a reductive society, we believe all truths already exist within a forest of mirrors called the Internet. So as society reaches toward a hyperreferential, hyperefficient status and Hobbesian ideal, we leave that which gives us the power to actually live history, that lasts longer than the engagement in the image that stimulates a history to be made. How can we have post-Internet art if we have not truly seen the consequences of the Internet? It is impossible to find truth without perspective unless you are sourcing the emotional thread that has existed for time immemorial. Place the art objects we value today in the trash for tomorrow's generation, and let's see what survives when they must choose what is art and what is not.

Art is larger than context; it's larger than the negation of Beauty and a dialogue with the posts and the antis. Art is the only unquantifiable asset left to us, the only thing visually within which we can find a refuge for our humanity. With the invention of the personal camera came the negation of the image as art, and with the globalization of the camera and the supreme access of the image comes the power of the curator. And with this division of art object and regular image comes the emphasis on context and intention and credential. And with the emphasis on context comes an art object dependent on its framework of thought, and a populace who can no longer understand where to place their value. And with this comes the death of the infinite and supreme unhappiness and the rise of art that speaks to the infinite itself. Art that transcends words, and museums and the dumpsters of the future. Which is somehow preserved in the mind, which resembles a history lived rather than a history that's been assembled by those with a vested interest in it taking place.

And this is why I try, in my humble way, to paint figures, from the inside out. Why I try to use surface and tools to render something that in turn renders my identity. Why I try to build a vacuum and paint not from a negation of today's culture, but as a way to feel a truth

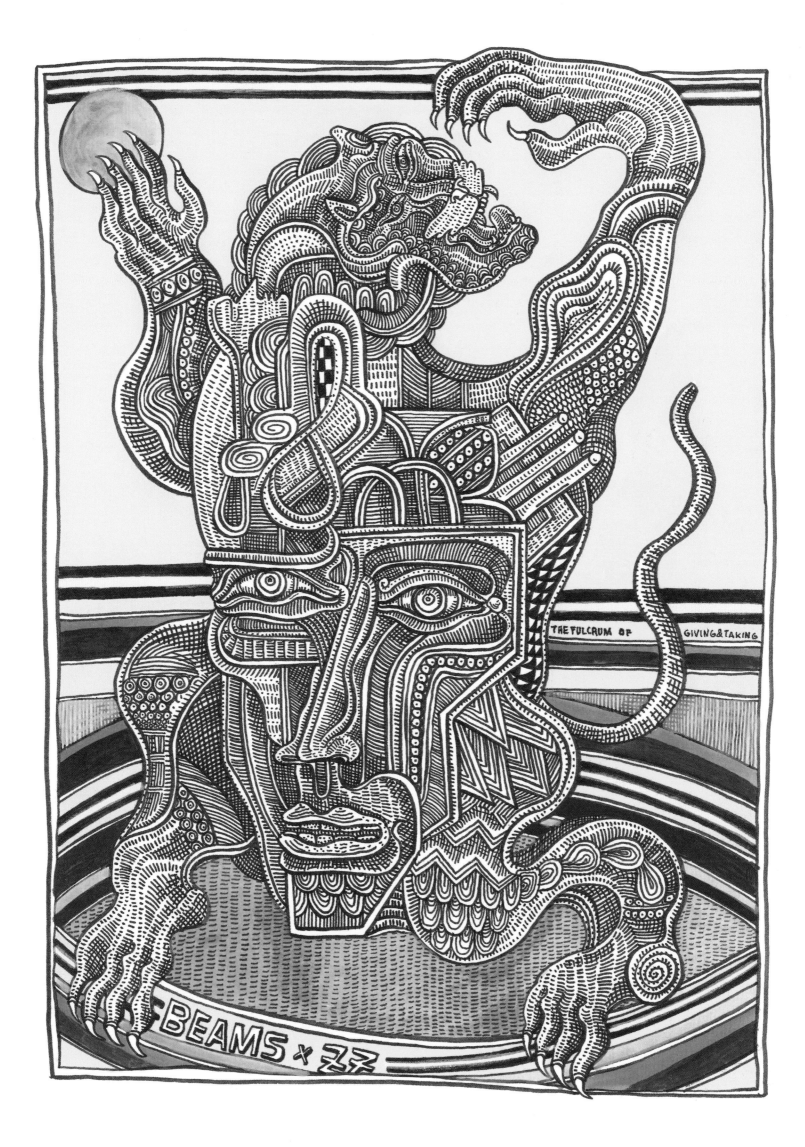

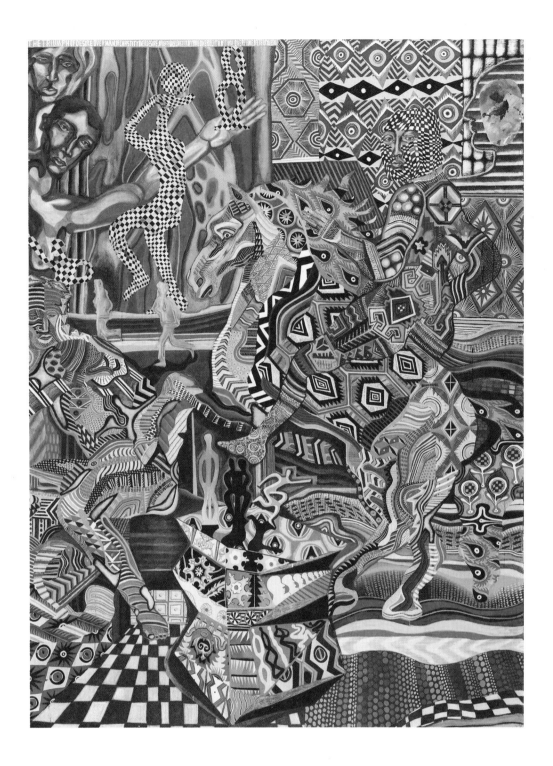

I can never articulate. This is not art Brute, this is not outsider art: this is art free of context in the age of mechanical reproduction. These figures are experiments, are testimonies to the beauty of contradiction, to the inconsistency of life, homages to memories, fractures images and emotions that have made it into the vacuum. These are made as an attempt to reach toward the essence of karma and spirit, to provide an infinite through the window of an image. To serve as a starting place for thought, not as a search box toward the known. These are paintings that come from inward, and go outward, and will keep going for as long as humanity deems them necessary. They will carry your secrets, your projections, your ideas, your doubts and desires—this is the canvas as surrogate soul and memory. A piece of a mys-

tery that cannot be solved, a nod to what we can never figure out, or plot and productize while keeping that which defines it alive. These paintings are yours, not mine.

And as images and alternate realities, and facades without foundation continue to surround you, it is my hope that these images can serve as a rudder to navigate that truth which is a priori. There is a synthetic seduction in the media that is so easy to consume, a feedback loop that closes tighter with each engagement, a satiation that fades the more we see the presence of the drug as structure itself. And in this ease of consumption, the palatable happiness fades with the lack of effort to consume. We are defined by our efforts and struggles, and without them happiness is impotent. It may take years of this slick pseudo-culture until one craves more struggle, but it will come and the struggle will not be in the referential, but rather in the vulnerability it takes to engage something emotionally.

And as the world becomes more efficient and more quantifiable, that which remains enigmatic will last and that which doesn't need context will always be free.

I TRIONFI

The title of this piece is an homage to Petrarch's long poem *Trionfi*, written in Milan during the fourteenth century. I chose this as the crux and title for the work because it has been said Petrarch is not only the father of the Renaissance, but also a catalyst for humanism. The notion of triumphs also tapers into the idea that progress only forms in competition and that if Italy had been unified during this period it is possible the Renaissance would never have taken place. Therefore, it is the competition between opposing powers, the tension between triumphs and human necessities that guides and motivates human progress and evolution within art and culture.

Within the work you will see references to many of the points of power and tension in this era of Italian history: the Guelphs and Ghibellines, Leonardo's Sforza horse, Boccaccio and Guicciardini. In essence, I collapse time within painting as I collapse depth through pattern. Things left to the caprices of history are often removed from their context and left vulnerable to the discovery as an isolated event. By compressing the inspirations and influences Italy has to offer, and using Milan as the nexus, I wanted to create a work viewers had to pick their own path through, as though it were a library of knowledge or a simulation of the globalized nature of the Internet. It was also important for there to be myriad materials and styles present in one painting—faces left half-rendered by the computer, knowledge left partially uncovered—because my exploration of this knowledge is so eclectic and imbalanced that the surface had to parallel my investigation of its source material.

The way we discover knowledge today is so piecemeal and partial due to the computer that there is a collapse in time and space and etymology that can only be represented by a fractured image. I felt it was important to read a novel by Don DeLillo during the creation of

this piece, as he is an author who not only examines nostalgia and broken histories, but is also a second-generation Italian immigrant to the United States. How does his heritage follow him? How are things translated through place and time yet still preserving the Italian sensibility? It is a feeling that is a composite of its histories and manifests itself in its people. This work examines the influence, the impact, and the transcendence over time that a creative society can have; therefore it was important to see its roots present in contemporary authors as well as ones from that period itself. There are nods to the Memphis School of Italian design, the House of Visconti, *The Plague*, and Mussolini, all of which, through a flattened surface, use a mandala effect of the work to immerse the viewer in the ethos of Milan. The triumph of eternity is with the struggles of the rest of the triumphs, yet without the fight for each, the eternal can never exist, and this influence of the eternal influence of Milan's history is something that bears great power in our world and the society we live in today.

PROJECTORS

Why take shortcuts, when it will just shorten the life span of your work? It's not about the image anymore; there are too many images in order for them to have any impact as just a result-based process. The purpose of the image is to dig into the consciousness by exposing a common humanity within the unknowing mark. Shortcuts are a disservice to your creativity, because it is your struggle to create that defines your creation. Take the struggle away, take the deficit between eye and hand away, and style will ultimately disappear.

A FAREWELL TO COMMERCE AND ART

My first belief was that art should be accessible through products in order to broaden the spectrum of inspiration through the catalyst of a purchase. It was the idea, as naive as it may sound, that quality speaks through art louder than the product itself, but in project after project—my intention aimed at sharing my ethos and work with the world—I've seen commerce corrode my initial intentions to something so hyperrelevant to their ends that it lost all sense of timelessness. I have seen company after company check the "art" box on their marketing plan, and I have often heard agencies and publicly traded businesses say that they don't have enough money to pay an artist but the project would be a great opportunity for me to market myself.

Self-marketing, exposure, and brand involvement lead to the decay of true vision and potency. Somewhere through this commercial spectrum, art is cropped, changed, packaged, and dismantled to where it no longer contains the soul that was within its initial intention. Instead of telling me, "It would be a great opportunity to market yourself," they should say, "It would be a great opportunity for us to use your identity and authenticity to market our products." Opportunity cost in this instance is too high; it strips away posterity as a possibility. It dates your work for a small sum, because it inextricably links your soul's expression with a commercial machine that was never built to generate anything besides eventual landfill material.

Art has the capacity to be timeless, as do products with care, and products with care are not products at all but design objects. Things that escape a bottom line, and a margin and a marketing budget. Things are things because they have an element of soul attached,

a pre–industrial revolution flair. Products as such lack the personality of an individual. Look at the differences in the words *thing* and *product*: one ineffable, overarching, and open in its etymology, one redefined by the industrial revolution and mass production.

We are generating culture so quickly we don't have time to be mindful of what we are creating. There is a craving like never before for consumption and voyeurism, a void previously filled by the trials of the hierarchy of needs, and now filled by products and consumption. There are "right answers" in today's civilization. We breed mediocrity and greed, narrow thinkers and products. We may find new ways to sell things and new things to sell, but what will outlast this decade? What will not be acquired and rolled into something larger, what will not be dated by its users, and become antiqued after its consumption? Supply and demand were one thing when the world was not globalized, but examine supply and demand in information, in creativity.

How many times can you help a company sell a product before your name, within the zeitgeist, resembles a free association with that product itself? A product that is landfill bound within your lifetime, and which people tire of because of its prevalence. We desire that which is hard to get, and we remember that which we could never entirely have. Our whole Western world is built toward efficiency, toward building a piece of originality into a product and making that product as delicately situated within the spectrum of saturation and desire as possible. Great art must lag behind efficiency. It must stand outside the way of the quantifiable and become that which cannot be seen or had. It must be above the caprices of a market, and away from the cycle of products; it must be isolated in obscurity. Away from curators and marketing agencies, away from those who use the original spark to sell their own ideas. It must remain unquantified.

If projected value mirrors certain value-adds of institutions' and individuals' approval, and market play, and art become an extension of a society, it becomes relative in its quality to how much it is worth rather than how unquantifiable it is. And the more it is worth something, the more dangerous the risk of its disappearance within the relevance of posterity. And so I propose the trash test. Imagine all art is placed within a trash can and exposed to a future civilization. We remove context and value entirely; if a piece is removed from a pile of products—is distinguishable as a thing, a thing with soul—then it is art. Imagine what you would pull out. Would you remove this post-Internet art? Would you remove the items that mirror and fabricate a history before it has even been tempered by time? Globalization has turned much art into trash. It has overcontextualized in order to differentiate its product from the next, in the same way literacy and class went together in the Middle Ages. However, I believe it is no longer the amount of conceptual productization that distinguishes a product from the masses, but rather its power in lack of relevance and context. It is relevant for history particularly because it is not relevant now. Because we have produced a history that is yet to be crated just so we can have something to consume. We fabricate illusions based

"LIFE IS THE CONTINUOUS ADJUSTMENT OF INTERNAL RELATIONS TO EXTERNAL RELATIONS."

—Herbert Spencer

on other illusions and then build concepts based on thin air. We mold movements out of things, which we do not yet have the distance from to determine the relevance of. It is the supreme arrogance of man to write history before wars have even been fought today. It used to be a product of the victors and now is simply a product of the wealthy. No matter how populace-driven the platform, money always buys relevance even if it is for a minute. There is always some artist who is willing to exchange his unquantifiable soul for a moment of temporal satisfaction. To sell a product with his authenticity, until his authenticity is a product itself. And thus goes the cycle.

Whether we like it or not, art today has become about money, not about real history. And curators are the dictators of a simulation, building products from things that were once timeless. I am speaking of course about the system as a whole, not individual cases—of which there are many. We must live, and therefore we must exchange money for our hierarchy of needs, and who is to say this is not valid? It is history itself that begs for something less ephemeral. We must build something memorable. Not another version is Hobbes, but a tradition and an allegory and a past that transcend currency. Because marketing means nothing but an all-too-abrupt end to your relevance. Marketing turns meaning into decoration and crucifies quality for this god of efficiency we have created.

ILLUMINATED AUTHORSHIP

The Impact of Social Media on Contemporary Painting: Ideas on the End of "Post"

Before cell phones you could come up with a million reasons why you were late. The imagination flourished; there was wonder in anticipation and fantasy in the unknown. We would dumpster-dive for magazines in the back of record shops and wait for girls to call our houses. A glance or a memory could lead us down pathways of introverted discovery, and it seemed like the infinite was possible because our lives and interactions were not yet entirely quantified.

Then, a few years later, logging onto the Internet took a matter of minutes. It was brief exchanges with friends from school over AOL Instant Messenger (AIM) for the first few years, and then progressively, it became my entire night after homework. The necessity was to continue the dialogue, to format one's thoughts in terms of a text box, removing all mannerisms and replacing them with alterations in grammar, type, and punctuation in order to accentuate ideas. Vocabulary was pressing. Then it became important to learn the acronym. If you didn't know what one meant you'd have to face the shame the next day of asking a peer to decode something so obvious. And so emerged these parallel lives of the preteen. Compressing emotion into symbols and then symbols through a modem. With chat rooms the familiarity of acronyms became more important, and spelling decreased in importance. It became about how quickly one could render an identity in a cyber-environment through words. If your modem died you felt as though you were left out of a conversation. The subtext of conversations at school became cyber.

The serial nature of logging in and catching up often became more pressing than seeing that person . . . in person. You would meet girls at a dance but afterward only get to chat with them on AIM for a few months. The memory would fade, and you'd be left with a transcript of digital projections. Then came pictures, and the ability to alter pictures, and lie about

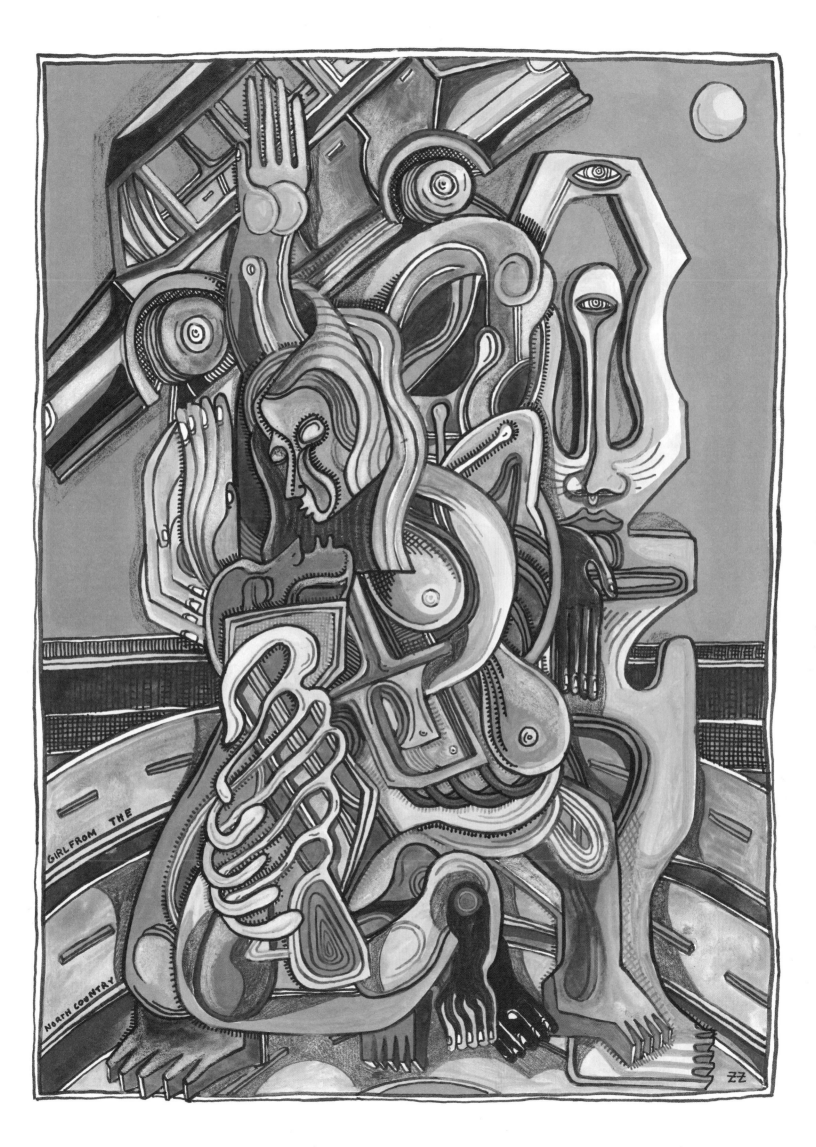

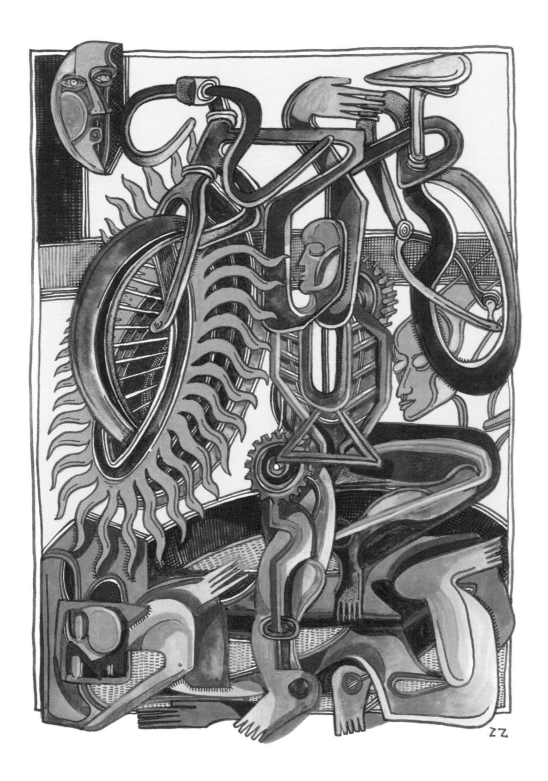

pictures, and the original identity became even more obscured. So by the time we had reached the earliest forms of social media one's digital presence was more pressing to maintain than a physical countenance. It was more about the customization on your MySpace page and who was in your top eight than who you spent time with. But still, reality was important. The Web for the most part still had somewhat of a gold standard of real life, and that held images in check, because images were proof, resolutions of the imagination that allowed us to deduce rather than expand upon. And so the two were held in stasis as long as laziness prevailed. Uploading images still took forever. Facebook still required a college ID and for the most part your profile was a place to share the life you captured rather than a place that

captured you while you shared life. And in many ways the delay of that inversion was merely due to the longer time it took with those bandwidths and digital cameras to upload an image.

But as soon as the camera phone came along, and the ringtone, we seemed forever tied to validating our existence through digital proofs. What was once an excuse from the imagination about being late for dinner was now the inexcusable because of the web of technology. The infinite and imagination was placed on a grid, and quantified. In one minute we could now find answers that had formerly taken a week in the library, and in mere seconds capture, share, repost, and comment on something we knew nothing about. The need to know and digital subtext of conversation became nodes within real life. Something we had seen in a digital space became real life, and then digital again as we followed the destabilization of reality.

And so during all of this, and with the rise of digital accountability, these unknowns that had once graced us with the freedom of not knowing perished. There was no excuse to not be well informed, yet there was too much to be informed about. People shared everything. They overposted, overliked, overcommented on things they had just learned about. Digital dating and voyeurism were so pervasive that people could sit behind firewalls and IP addresses and never know they had been examined while examining others. The stories we shared became our digital baseline. The things we liked became the indexes we belonged to. Then friends of friends became accessible, and then—why not?—people we had only heard of or stumbled upon. It was this melting pot of too much information, too many causes and stories and "friendships," too many texts and emails and scams. Forget the sources, and the idea of proof; search-engine optimization (SEO) became the statistical god and we its worshippers. The Internet was supposed to know everything, or at least it was just a matter of time until it knew everything. And so we shared less as popularity became quantified. We withheld and curated and shaped ourselves into a filtered, Photoshopped golem. We put it out there in a very measured way so that our stories could be followed in the swipe of a screen. Everything you were supposed to know about me you knew before you knew me and you saw it in the way I wanted you to see it. What was once crafted with words was now shaped with premium filters and false geo-tags. We had begun to rebuild a world from data that wasn't ours.

The system began to fold in upon itself. The digital sumptuary laws declared you must follow fewer people than follow you. You must "like" sparingly and be "liked" more frequently than you "like" others. It was the Ouroboros of social media, a Malthusian catastrophe of content. People began to live less and share things that were not theirs. Dreams became the currency of life. Who you wanted to be and where you wanted to go could be your identity. An identity of potentialities. Of things you had not read and didn't have time to read but would certainly like to. So the infinite, which was once based upon the imagination and the real world, was now a product of the images and data that most of the time others had put

into a system you participated in. The passivity of creativity increased, and with it the ability to interpret analog subtleties. We are skeptics but we choose our indulgences of belief because we still have to believe in the life we think is real.

Hence this takes us to the role of art in a quantitative world, and in particular the role of painting in an environment where the majority of images are witnessed for a flash of a second. How does a painted picture transport you back to when your imagination was at your disposal? The importance of aesthetics in art has gone on an inverse curve to the presence of the Internet in our culture. With the accessibility of the camera and the ability to alter images on the fly, painting has dug its feet into the pseudo-naive and the strictly conceptual in order to counter the power of the world to generate what would have previously been considered artistic. For what is artistic must outpace the common. The contemporary is always just one moment ahead of the now. It must be one step ahead of what the public can make in order to survive. You have filters; we, the artists, have anti-aesthetics. You value the image; we make the image so ugly you have to be trained in its theory in order to overcome its appearance. You can find the galleries; we are going to take the signs off. Oh, you like Instagram; we only use it to make a commentary on how little we care about Instagram.

We are the meta, a step above and a step displaced from the populace. Yet like the carrot attached to the stick, the behavior of the art world is as predictable as what it is connected to. It's the same deductive logic that we use to scour the Web for the information we need. And art is now in a position where it can no longer outpace the populace, although it would like you to think it can. The stick is shortening as the attention span of the collector dwindles. Things are quantities in this world, and we don't have time for games. We want what we want and we want it now.

So art has adapted into the polarized entity of mass culture, less from its free will and evolutionary trajectory and more because it's a niche market that has to satiate those who would like to buy into a subtlety that isn't grounded in history this time. For the art world mints history and movements simply to displace itself from the common, to try to lengthen its stick from mass culture. It does postmodern and post-aesthetic, and post-Internet, rather than taking the approach of anticipatory as it did in previous centuries. *Pre-post*, for lack of a better term. *Post-analytical*, perhaps.

We are quickly leaving the age of the critic as the SEO seems to be taking its place. Arguments about authorship and identity in painting are replaced with how much of a diverse impact your painting can have on the greatest number of people. We are returning to the *Vox populus, vox SEO* world. If the role of art was to comment upon, critique, and mirror culture in previous centuries, the prevalence of culture creation via camera phones and the Internet has rendered that task complete. Why generate commentaries on commentaries?

Art has the power to become pre-something again because the saturation of image culture and the Malthusian catastrophe of content is placing the carrot and the stick behind the horse. We are more than the anti-image as a response to the mass production of image.

"IF WISHES WERE FISHES, THEN WE WOULD ALL CAST NETS."

—Frank Herbert

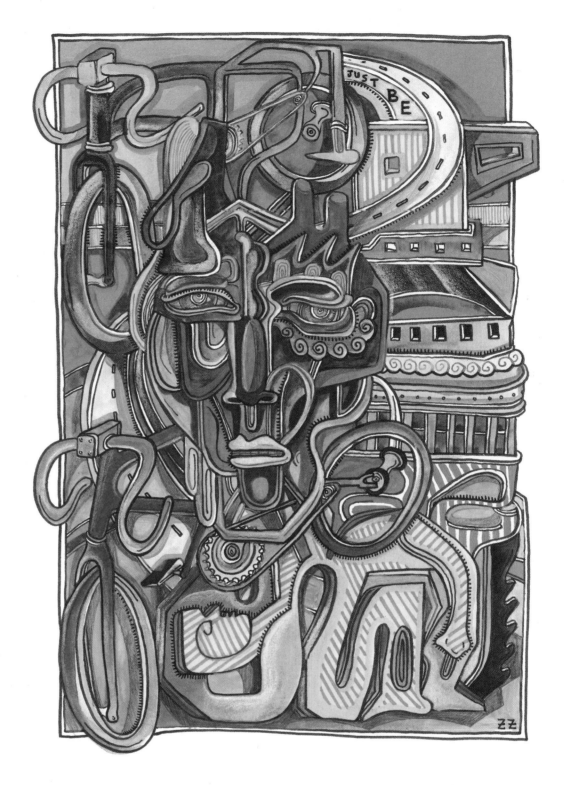

Art has exhausted its critical logic. We have reduced image to little more than idea. How does this serve to spark future culture if our currency is now image?

We must let the soul of an image without context be enough. We must weigh our works with the meaning we previously drafted in our artist statements so that medium and message are synchronous. We must prompt unquantifiable thought. We must be the one visual asset in culture that doesn't depend on culture itself, that abandons the dialogue that brought us to generating false histories. We must generate histories by being the fabric makers of a culture that is again infinite and unquantifiable. Make the public think. Build this movement as a non sequitur to what critical thought has decreed as art. Redefine art.

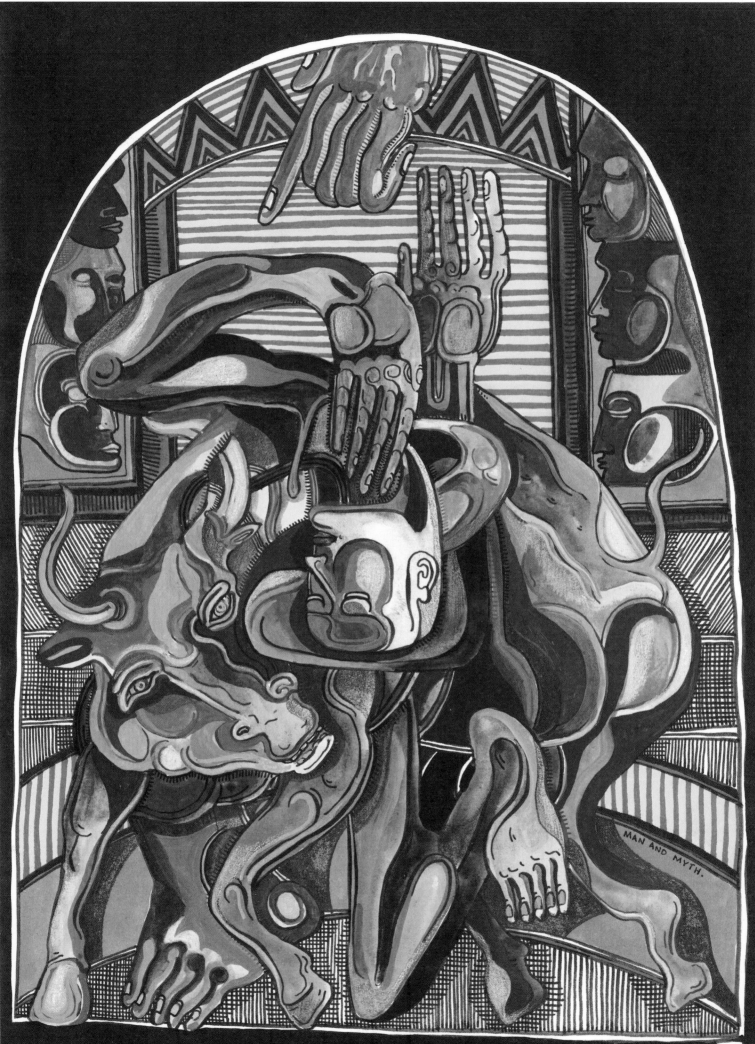

MAN AND MYTH.

"THE MODERN MAN REPLACES THE SUPERNATURAL WITH
THE NATURAL AS THE OBJECT OF CONCERN."

—Zio Ziegler

I know this is rash but it promises salvation for technique, for the creation of nonformulaic content. We are tuned to the formula now, aware of the narrative structure that produces an anticipated result, and this is slowly exhausting its impact on the human mind. It's the nonlinear, pre-something, true avant-garde creation that makes us think freshly and feel again, regardless of which reality we experience it in. There is a magic in art we can embrace or not, but which will prevail regardless. It's time to stop chasing the criticism and allow art to become an entity that shapes the culture we inhabit.

I believe that this change is already under way. Look at the rise of art without context, at murals and aesthetics. Now even corporations are searching for the last salvage of authenticity within street art to sell their wares. We respond to that which we cannot understand in one conceptual gulp, the ineffable, that which is impossible to homogenize or break into symbols. The power of criticism will undoubtedly flourish again, as will the next postcritical art, and even popularist art. But now we find ourselves in the final stage of our current critical cycle, our imaginations bulging behind the constrains of an antiquated structure of meta-post-post-reductive art. There is a disruption happening, so hold on tight, and welcome the next paradigm shift of the precultural.

This is a body of work that attempts to build upon the traditions of illuminated manuscripts and hieroglyphics. It forces contemporary issues in critical dialogue, the collective unconscious into forms that can be more expansive than conclusive. The paintings are mimetic by leaving their singular interpretation inside the viewer and by providing a fractal of visual opportunities to the viewer.

The series is built off the notion that once an interpretation of a subjective form takes place internally, it must be externalized in order to be validated as rational by the other viewer listening to the first diagnosis. However, removing the painters' interpretation from the analytical framework and allowing the painting to be examined as an artifact that must be decoded simulates our contemporary struggle of processing digital and dispersant information. Each piece of symbolism in the works serves as an open-source node, upon which the viewer can project, thus allowing the pieces to be points of resonance and discussion around issues that need multiple ports of entry. In their subjectivity, the paintings hijack the objectivity and "need for meaning" in the viewer and leverage their externalization into an existence far beyond the canvas. The viral qualities of the canvas can only be found by its resonant host, and in using the dissemination of the viewers' perspective turns the viewer into performance artist and crusader, supplanting the need for singular interpretation and allowing them to spread their own belief system through the catalyst of the canvas.

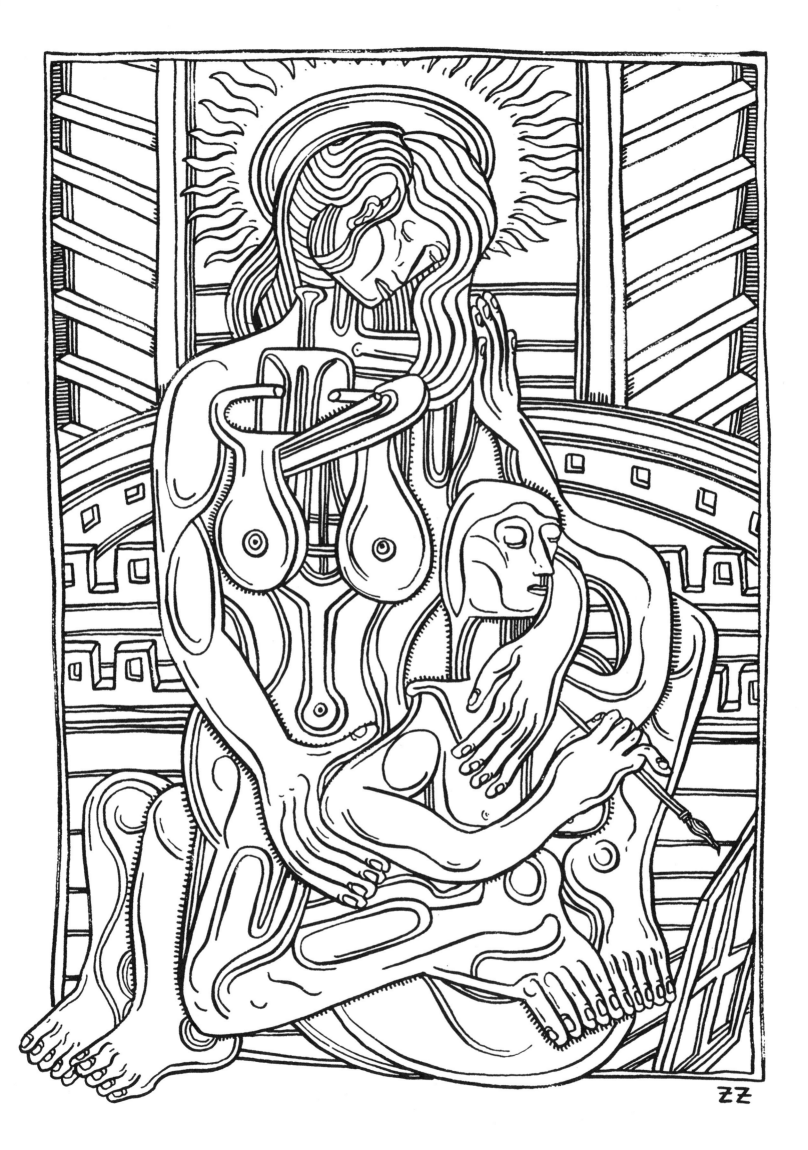

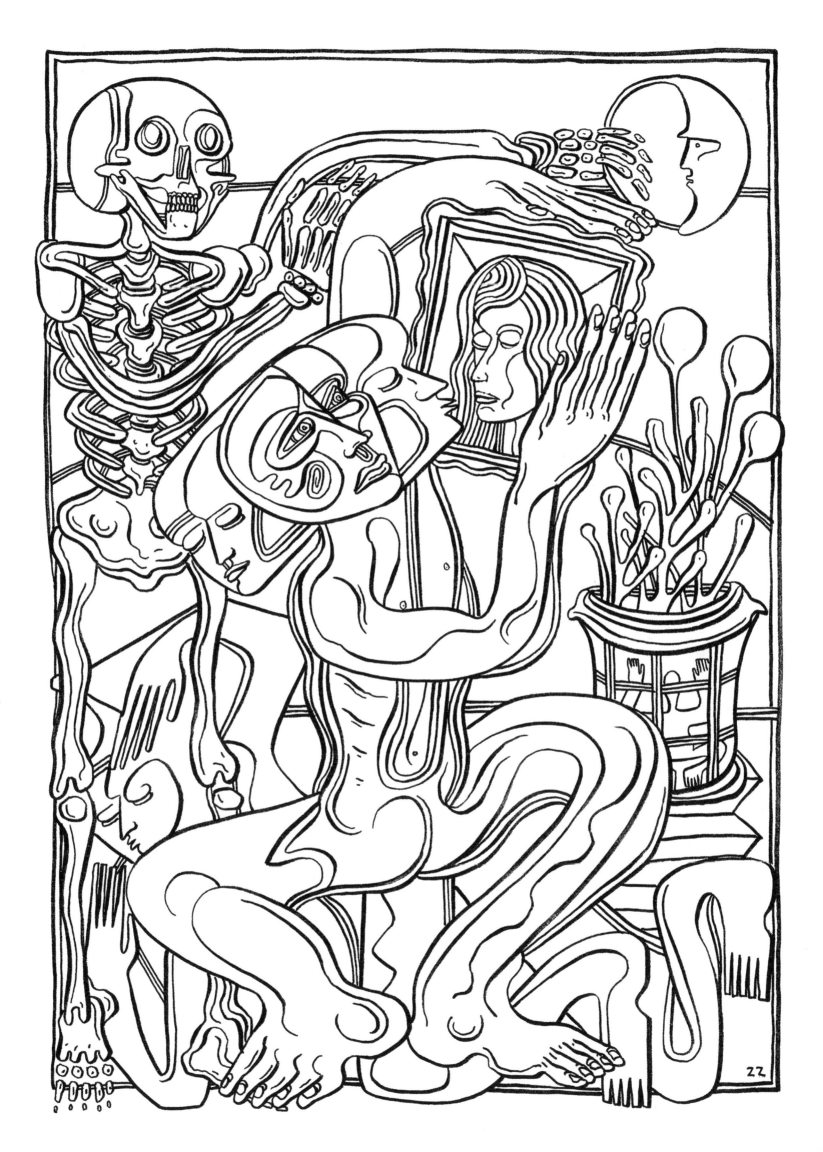

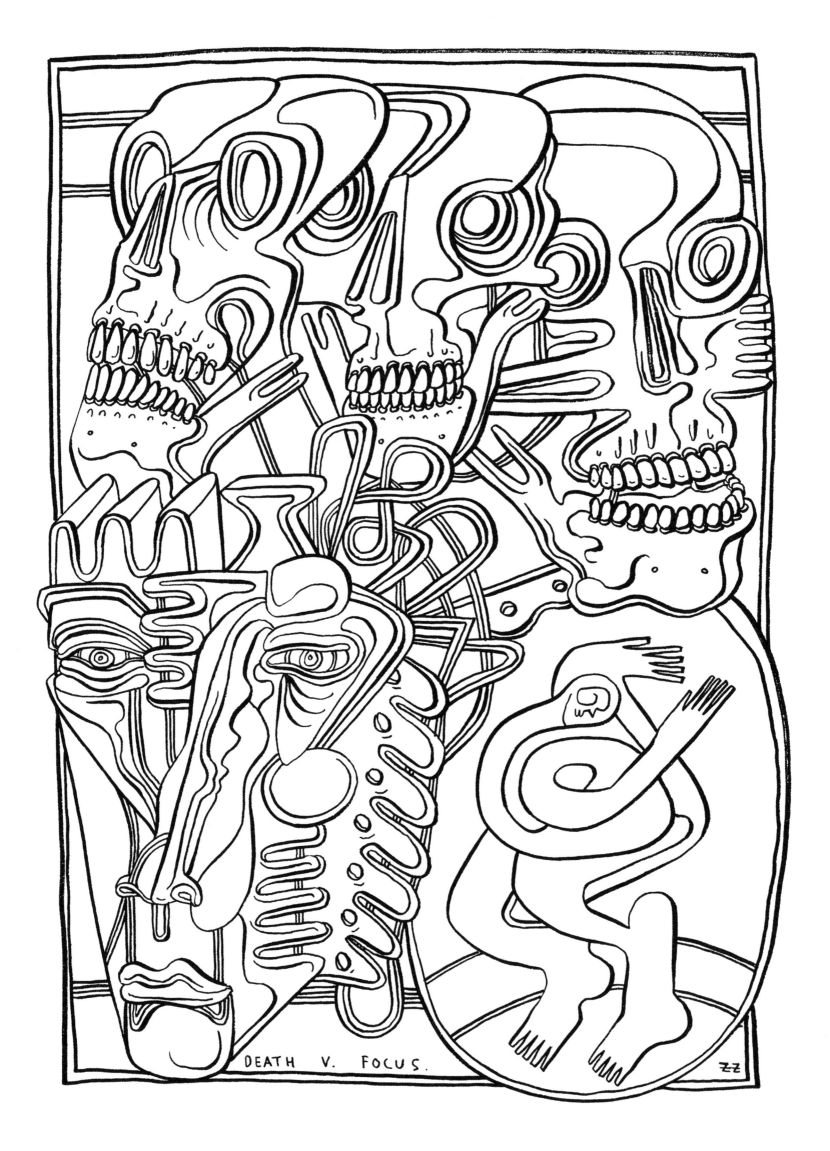

DEATH V. FOCUS.

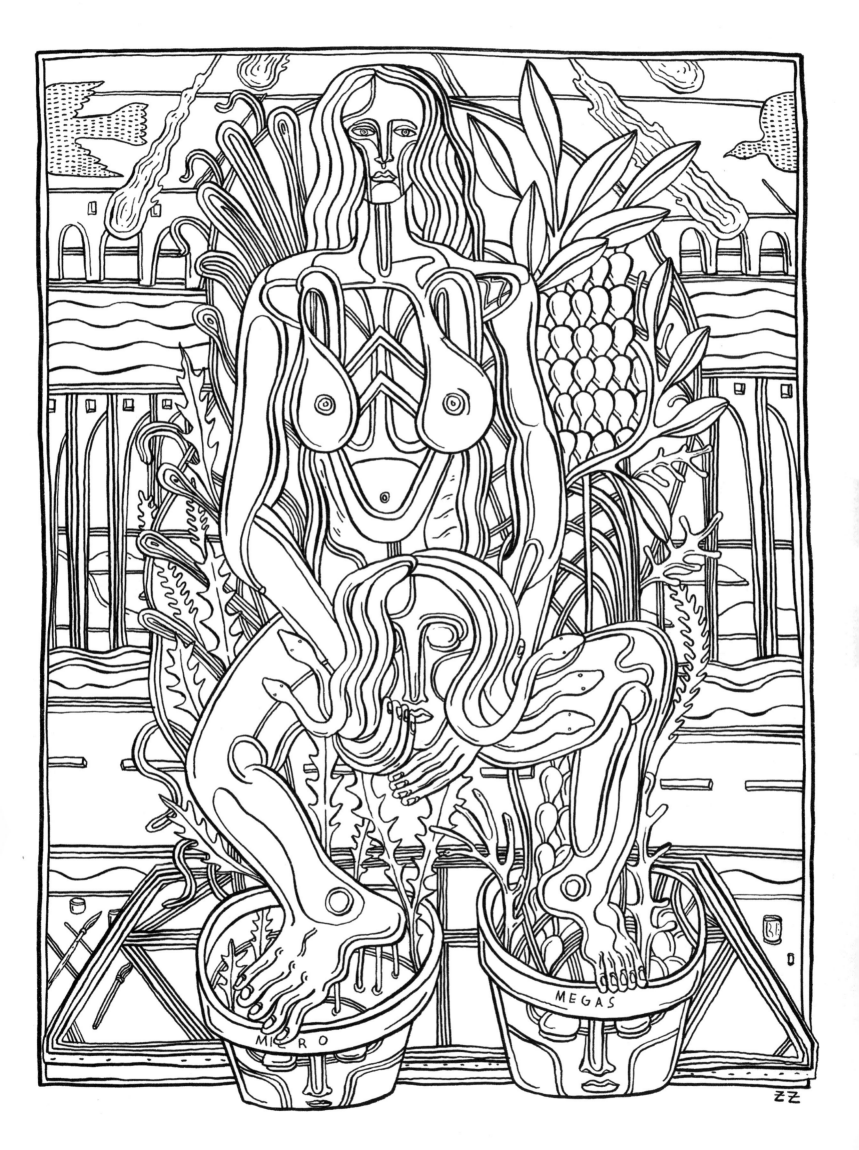

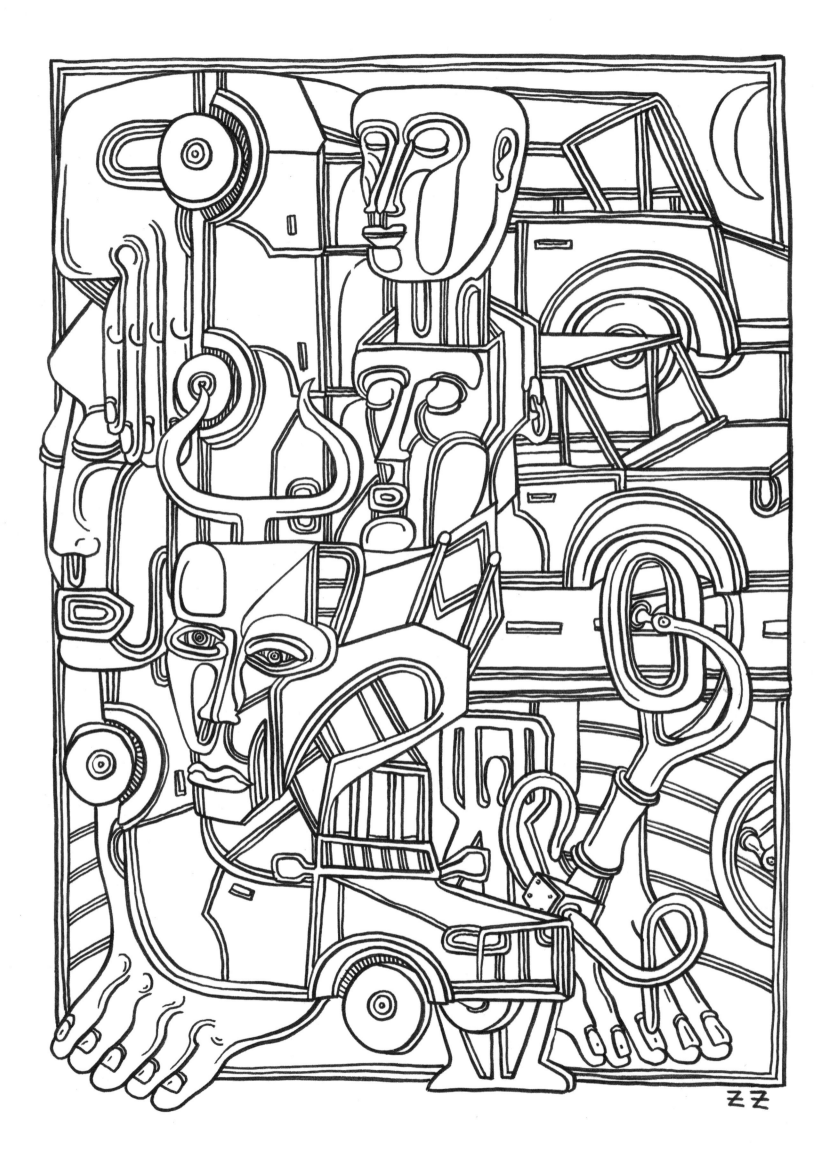

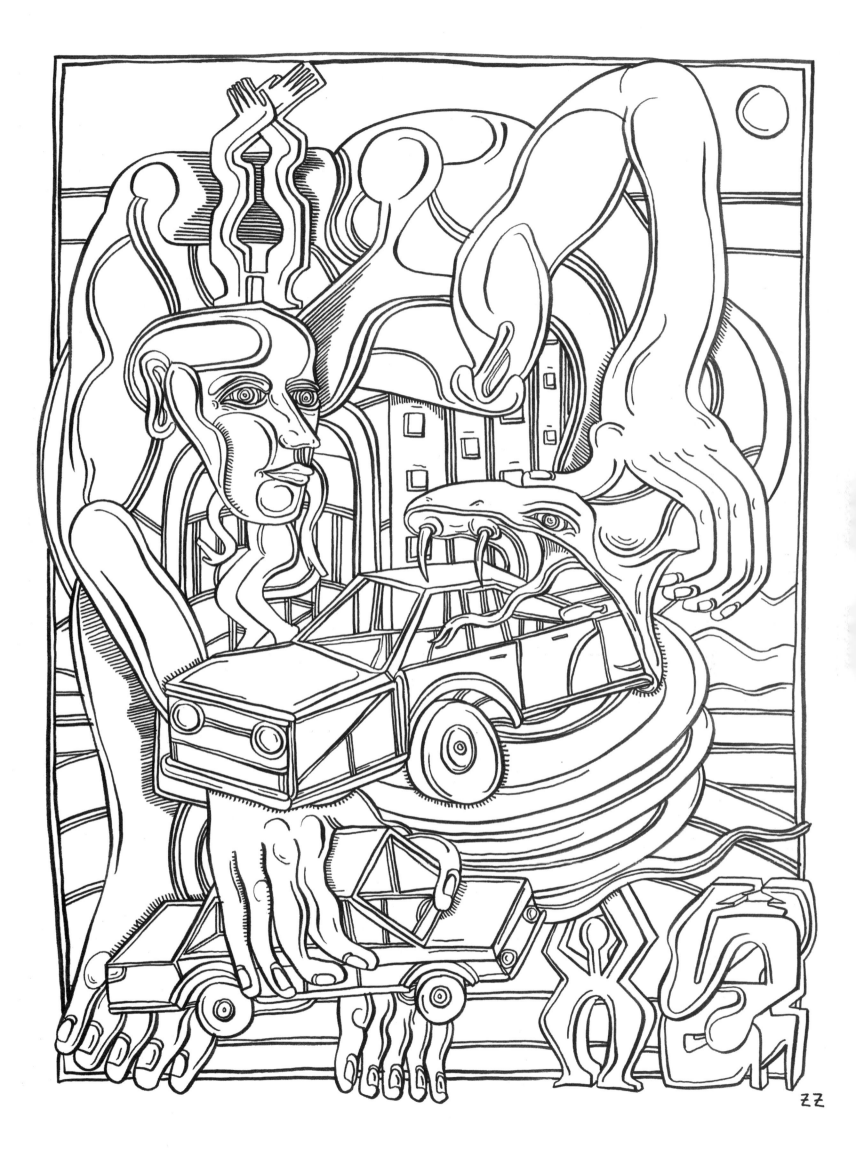

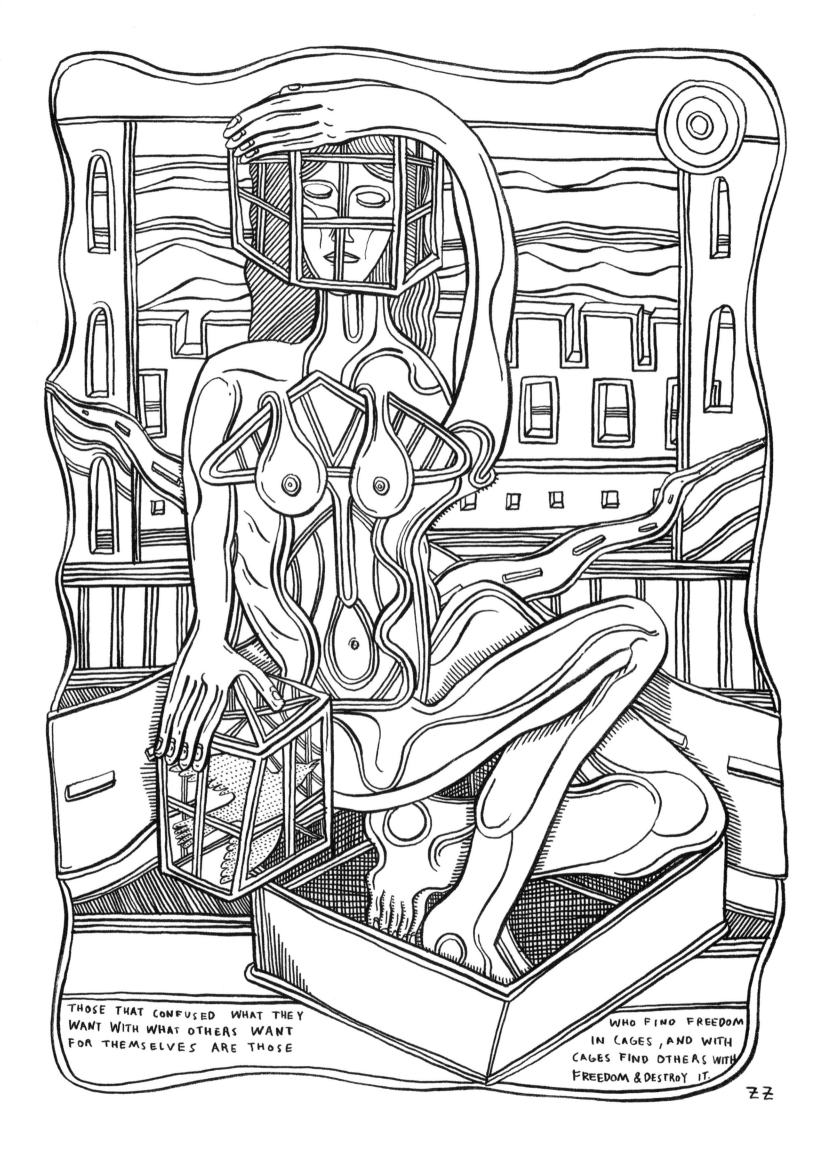

THOSE THAT CONFUSED WHAT THEY WANT WITH WHAT OTHERS WANT FOR THEMSELVES ARE THOSE

WHO FIND FREEDOM IN CAGES, AND WITH CAGES FIND OTHERS WITH FREEDOM & DESTROY IT.

ZZ

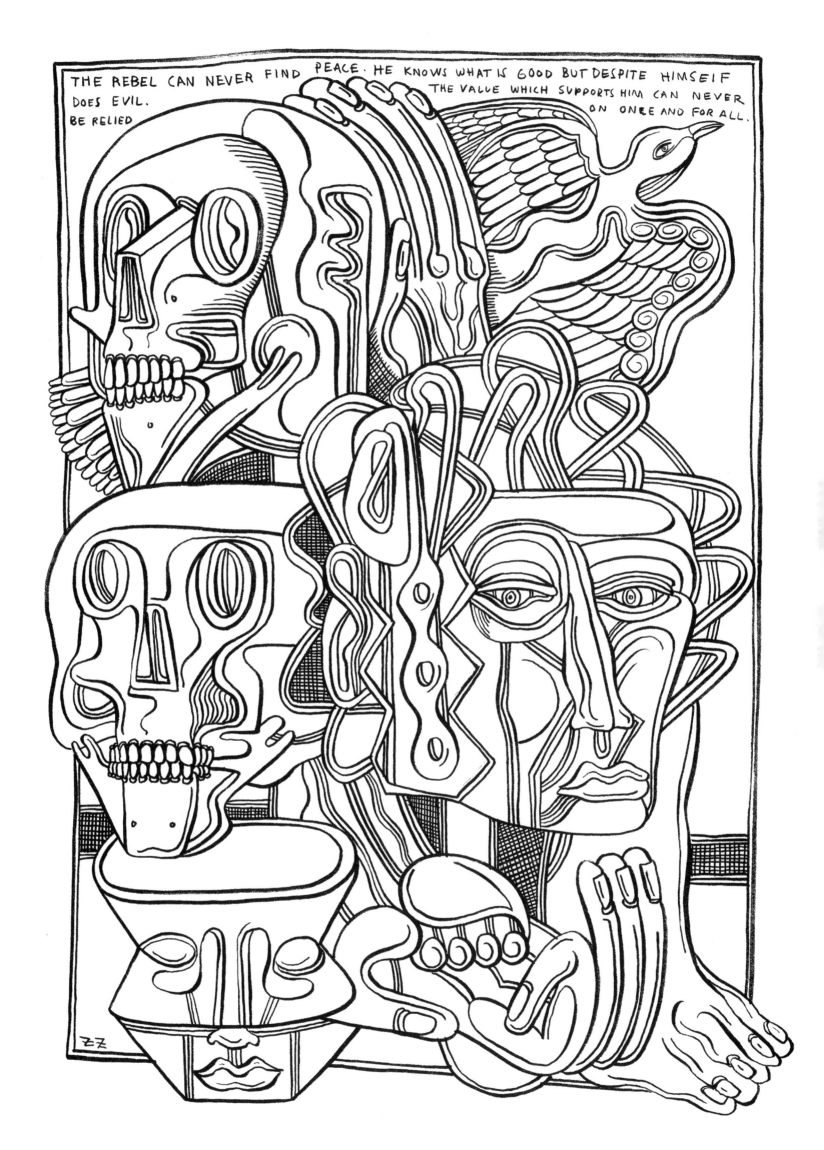

THE REBEL CAN NEVER FIND PEACE. HE KNOWS WHAT IS GOOD BUT DESPITE HIMSELF DOES EVIL. THE VALUE WHICH SUPPORTS HIM CAN NEVER BE RELIED ON ONCE AND FOR ALL.

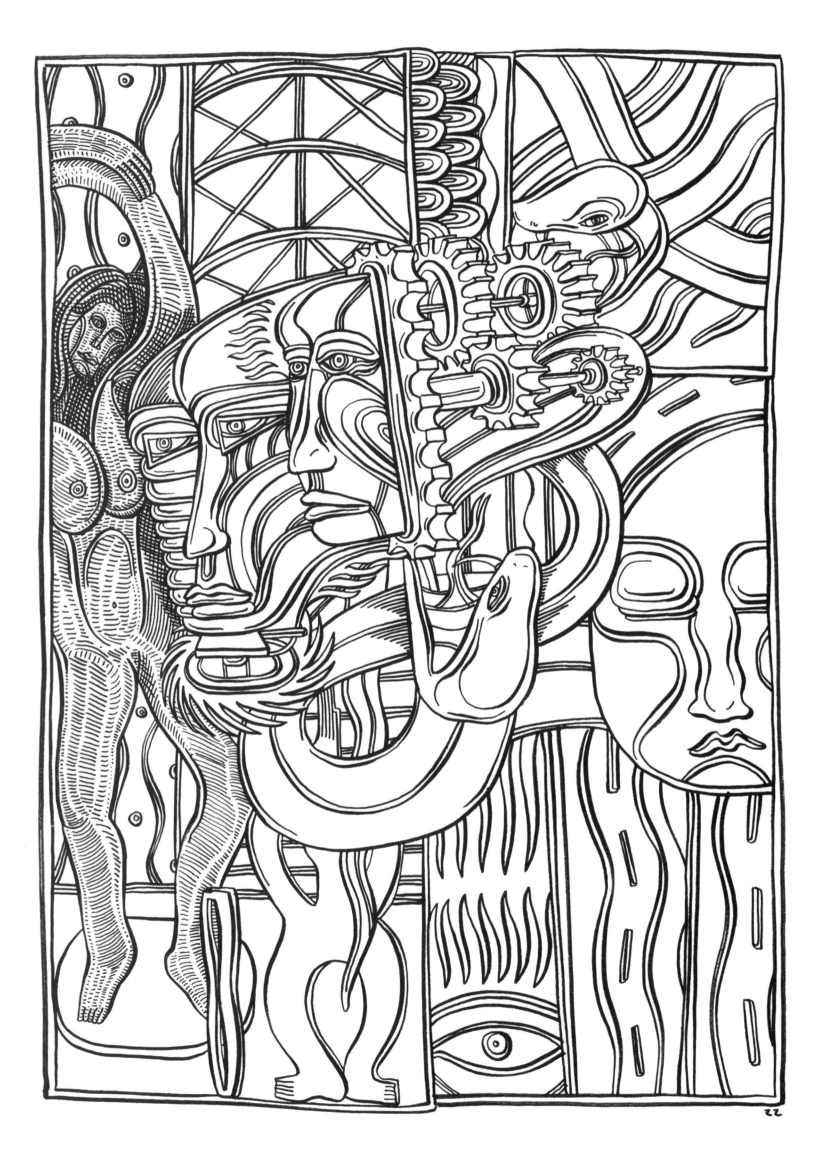

22

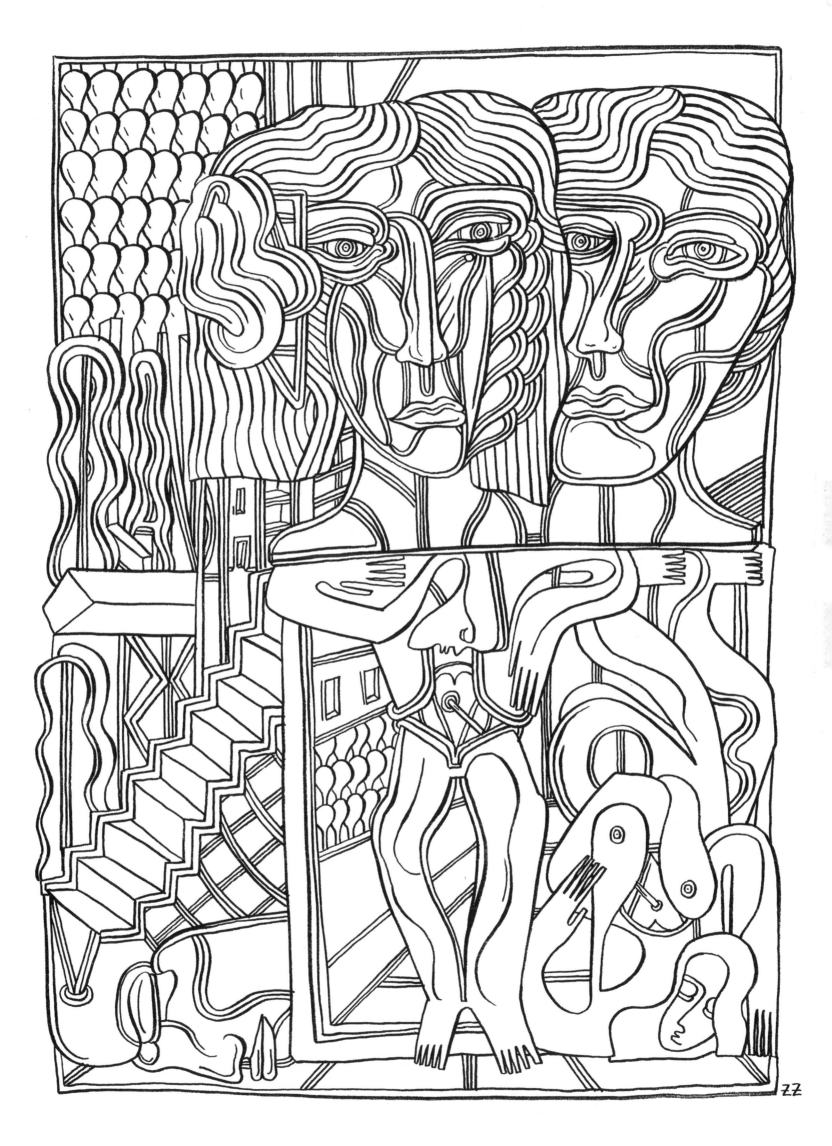

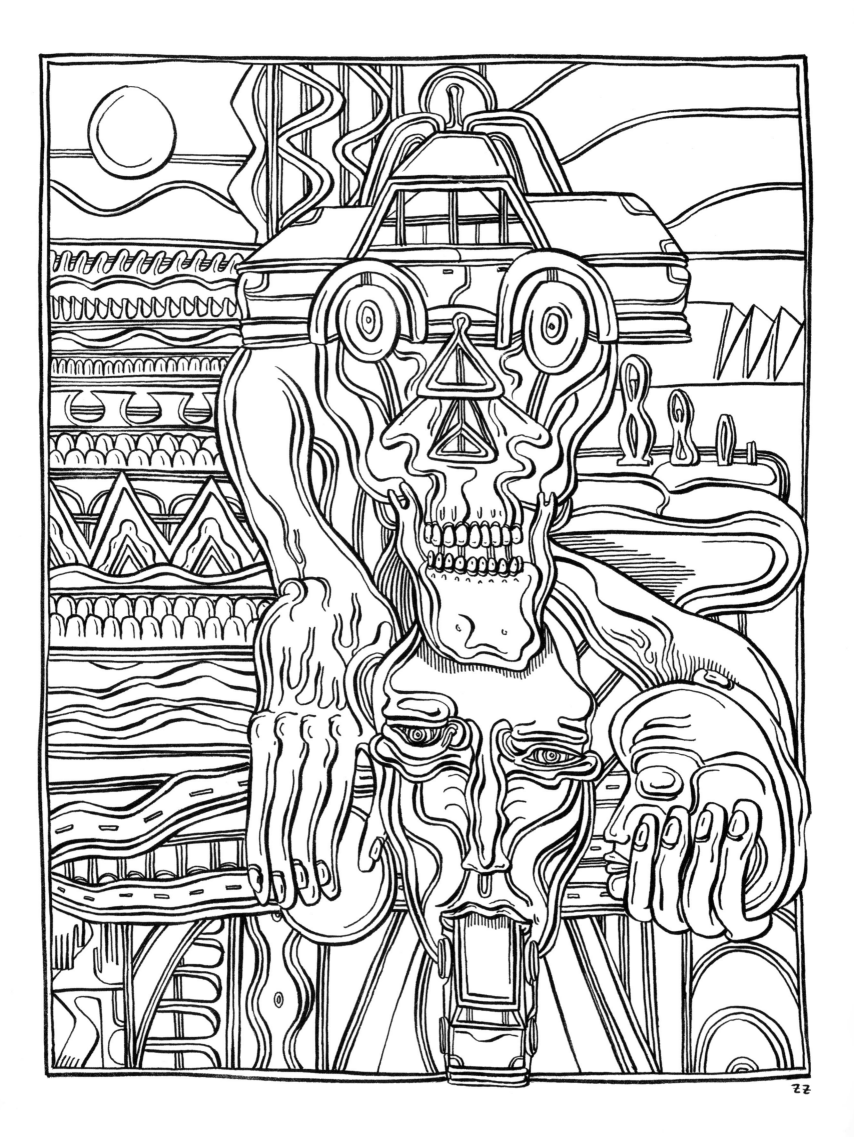

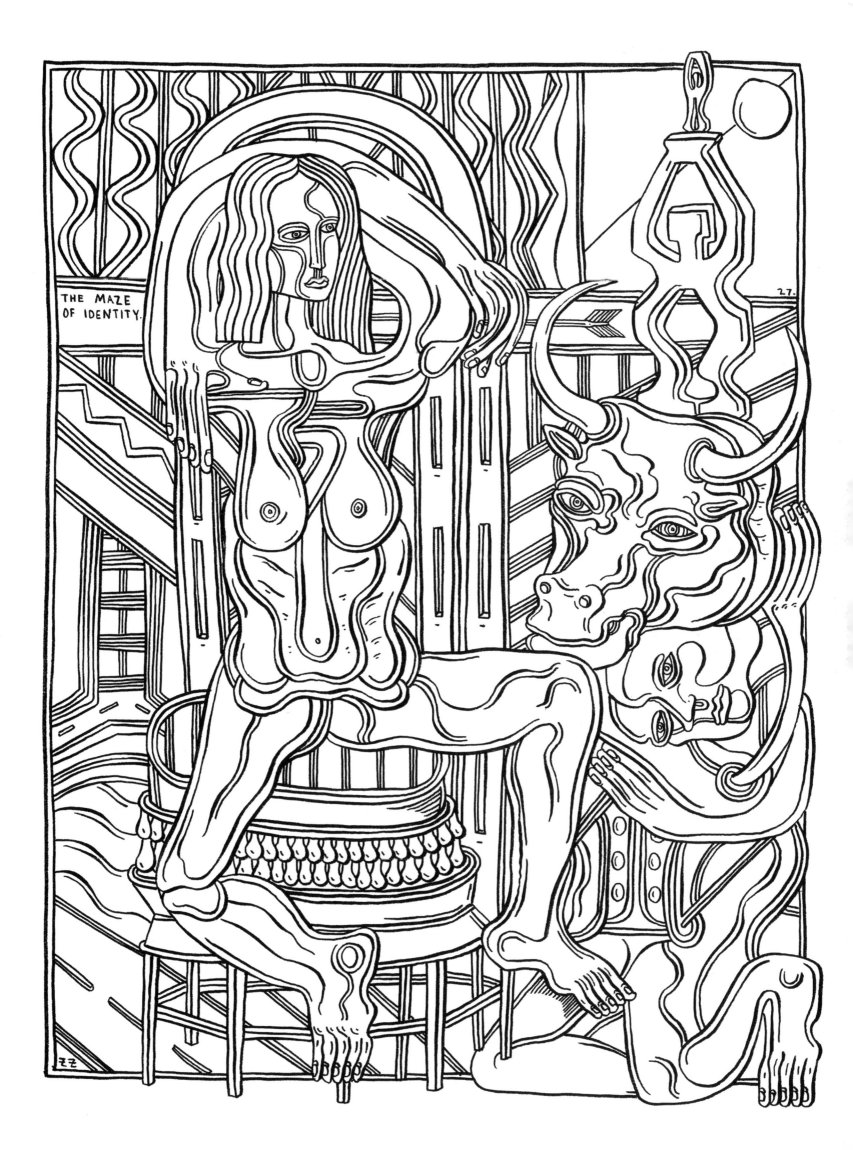

THE MAZE
OF IDENTITY.

27.

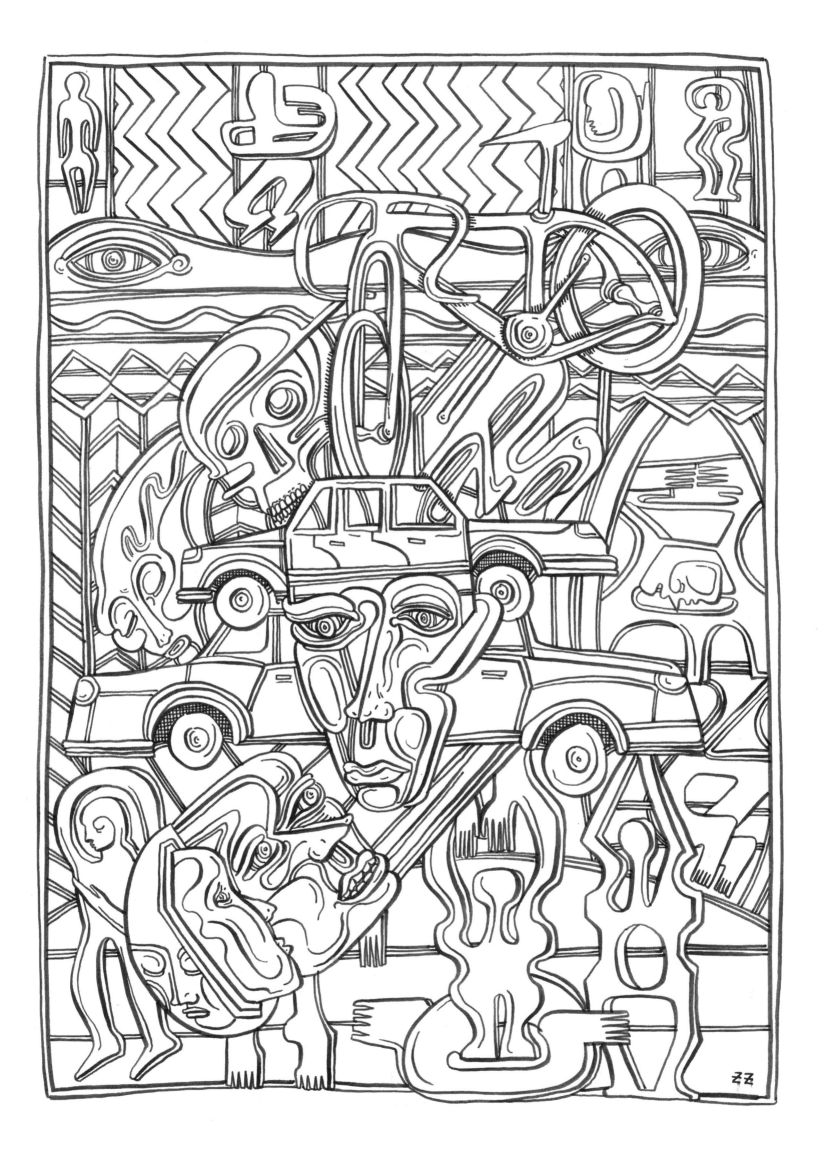

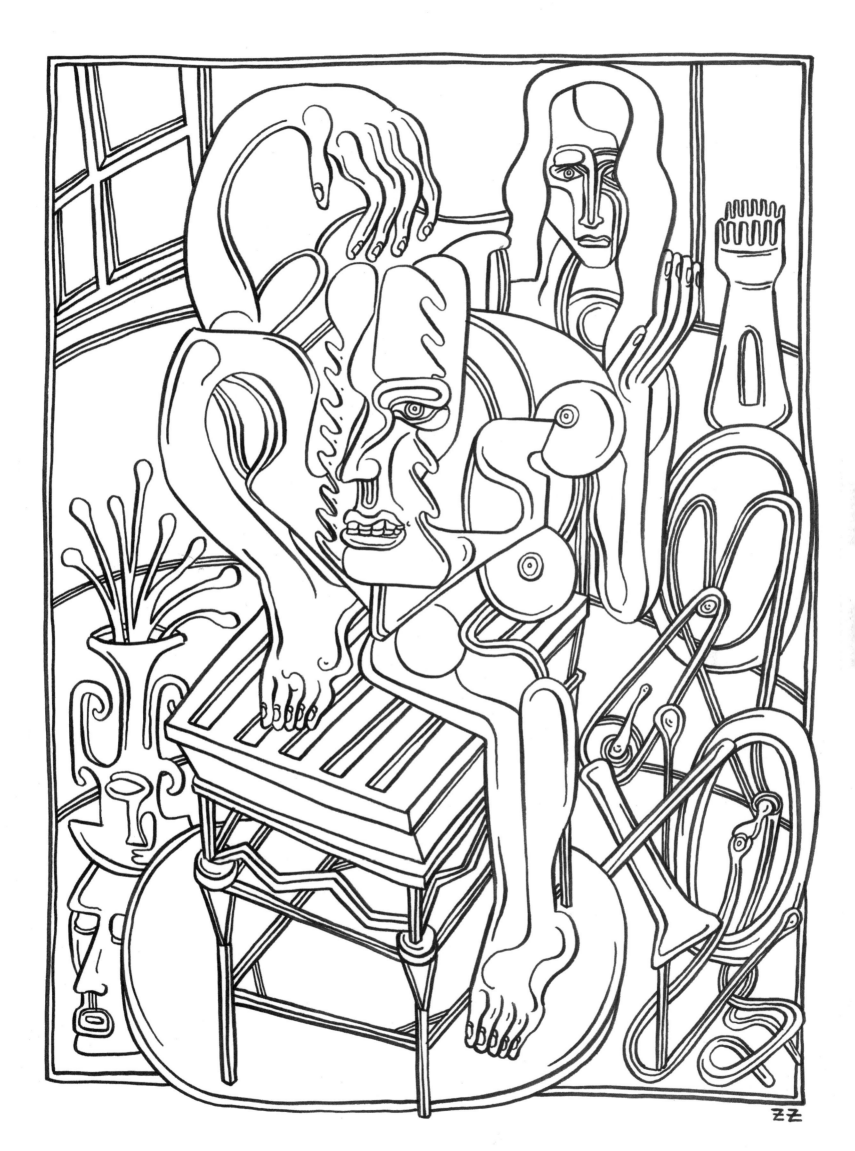

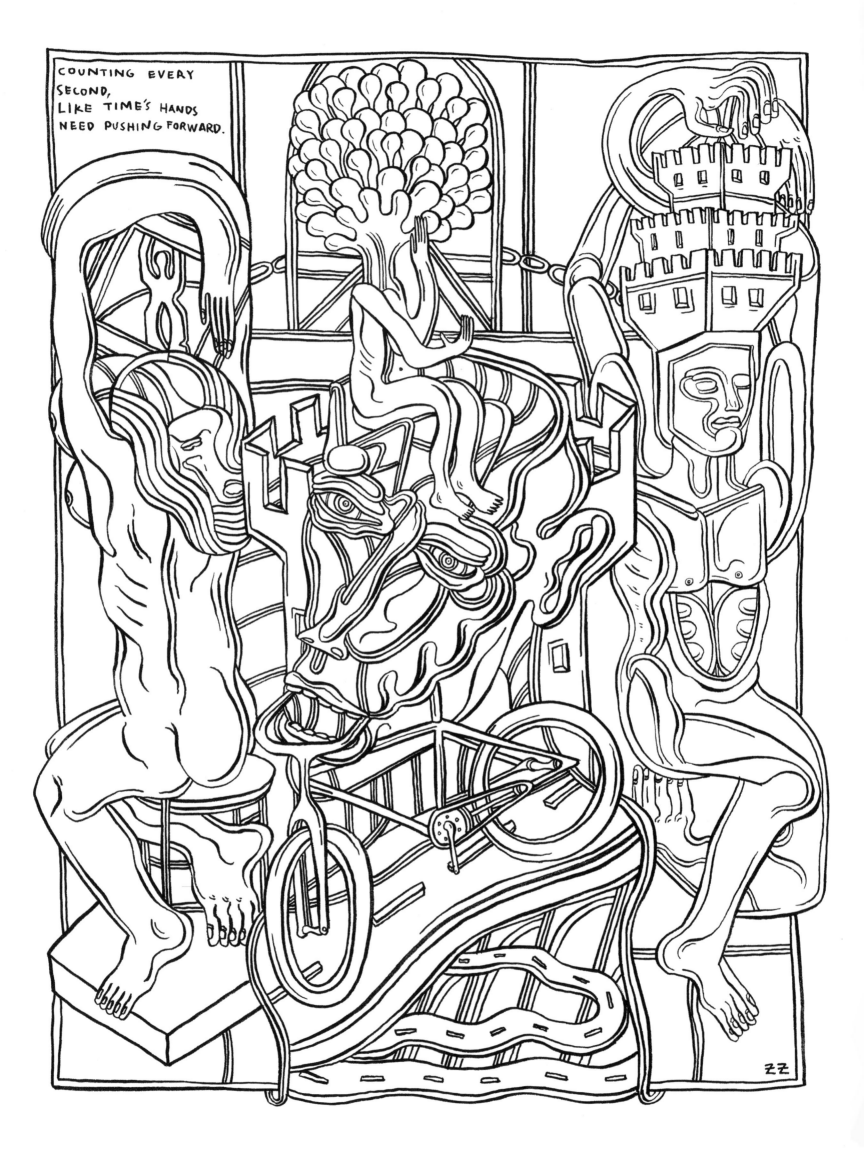

COUNTING EVERY
SECOND,
LIKE TIME'S HANDS
NEED PUSHING FORWARD.

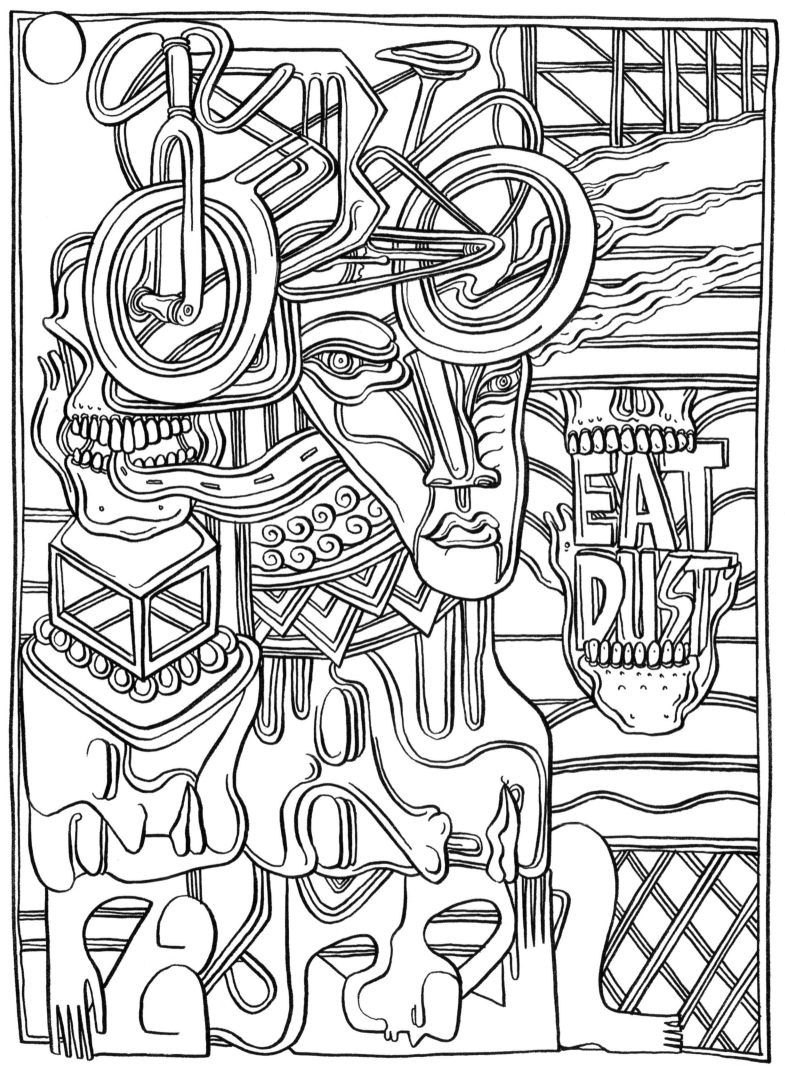

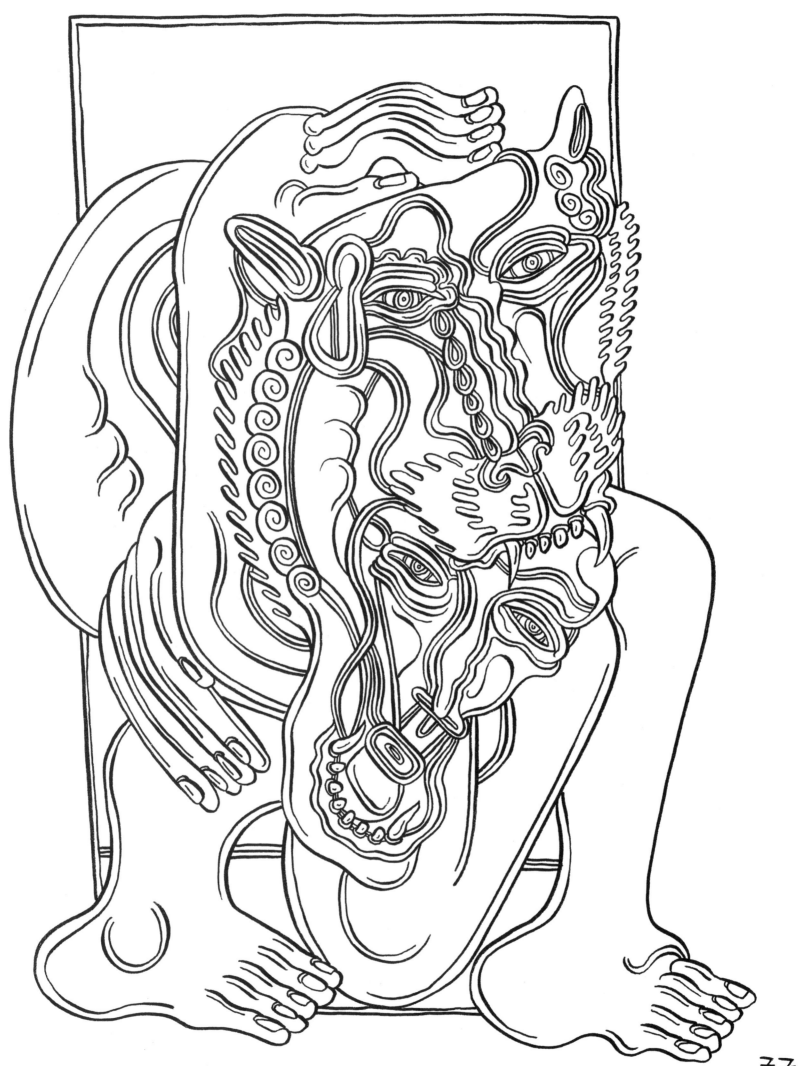

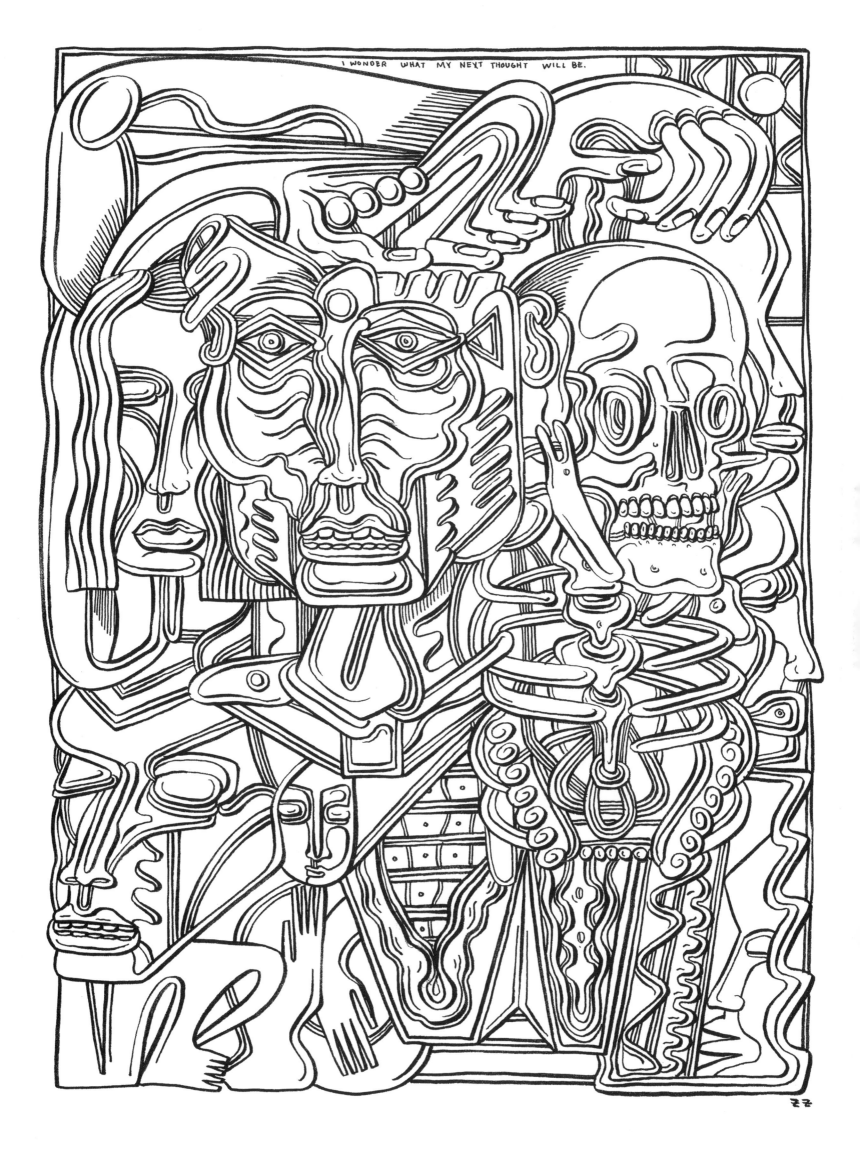

I WONDER WHAT MY NEXT THOUGHT WILL BE.

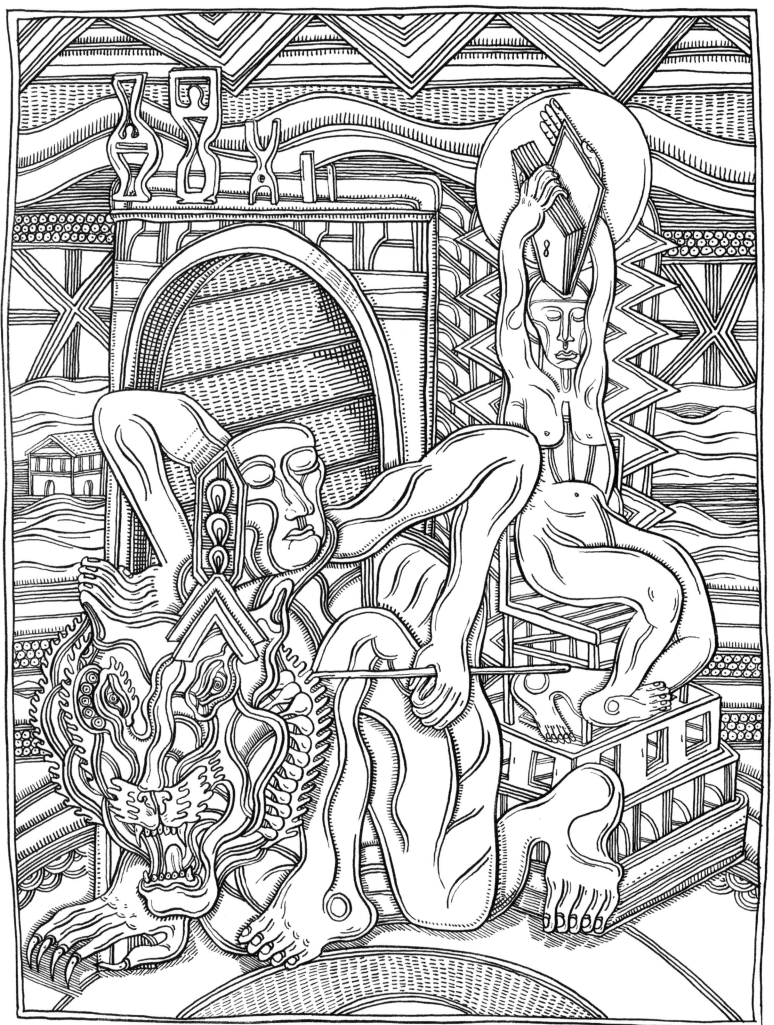

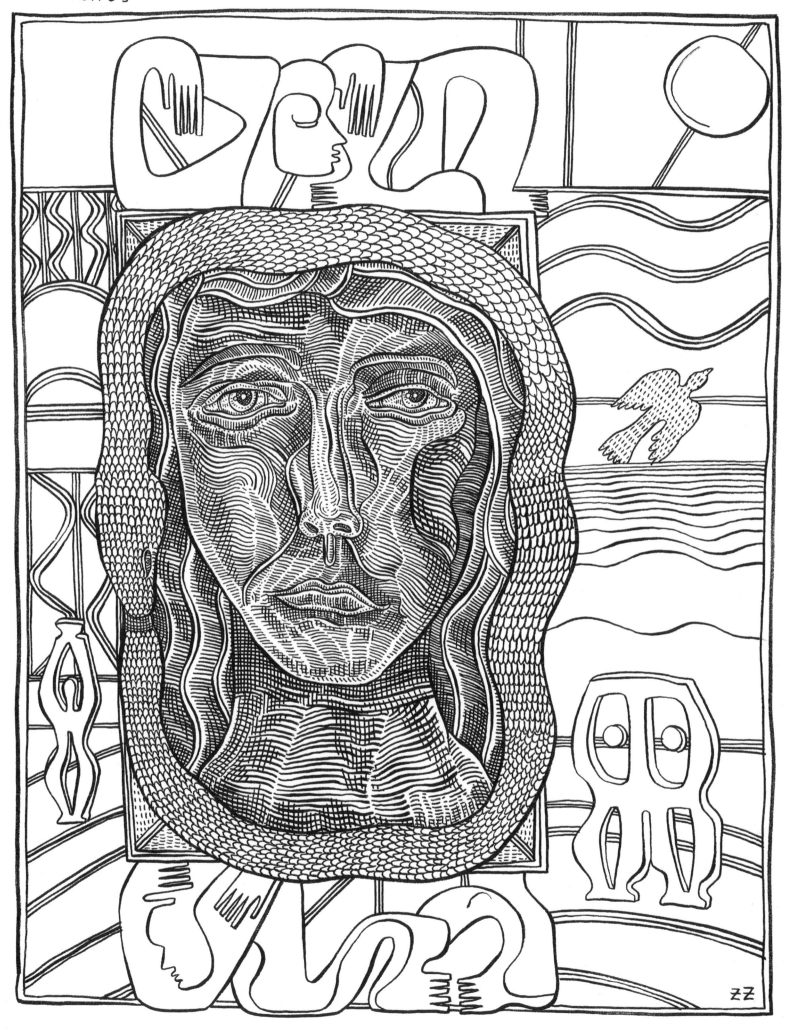

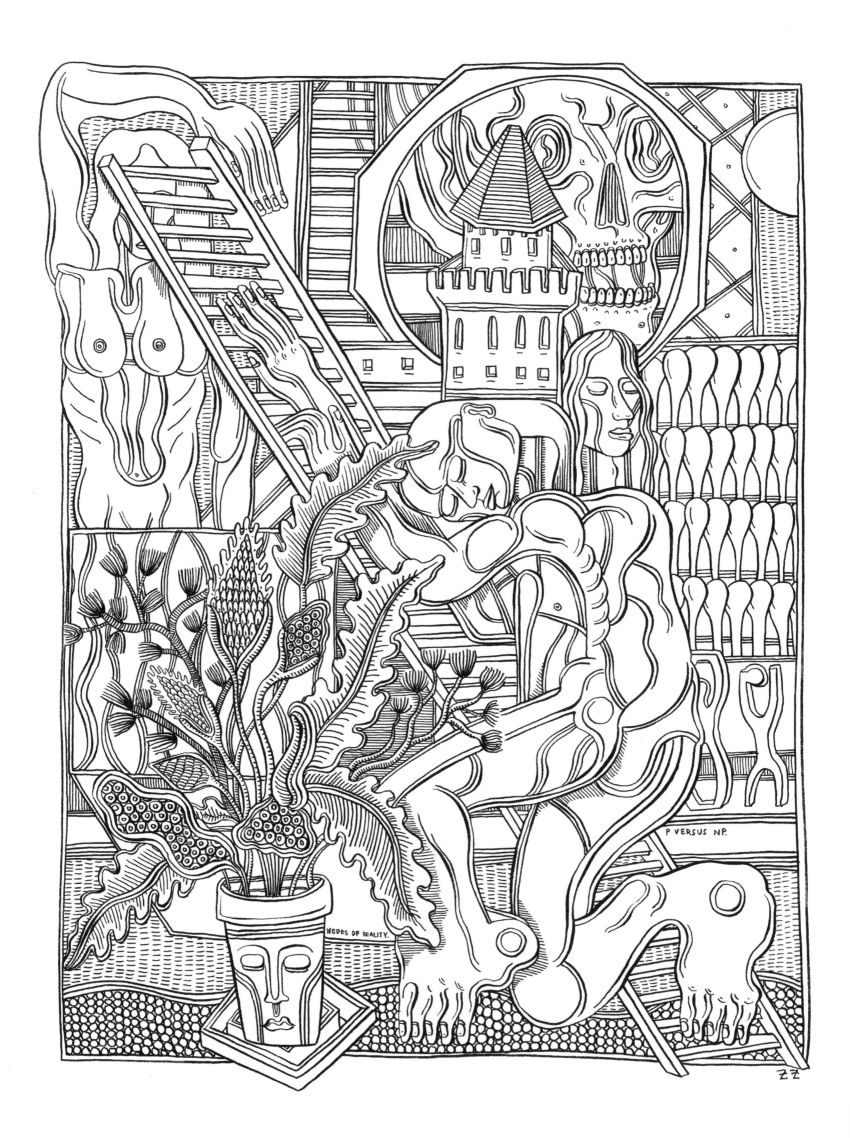

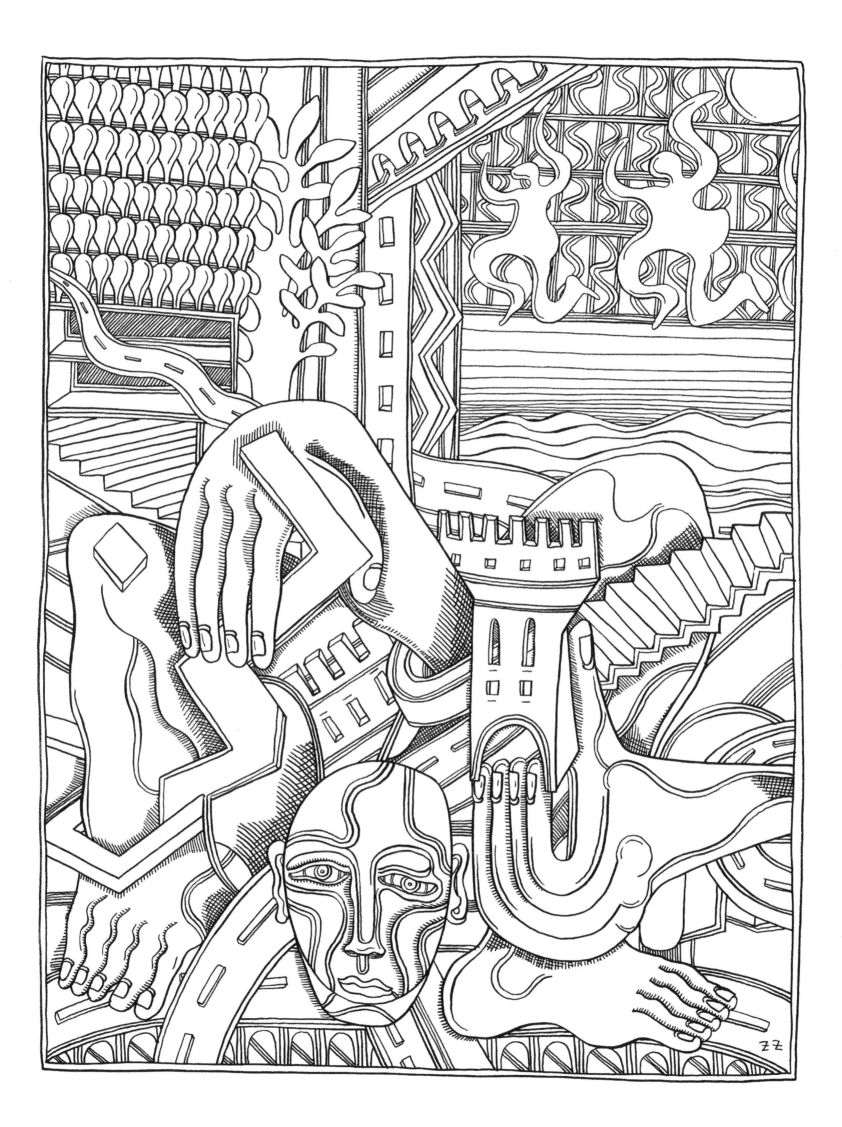

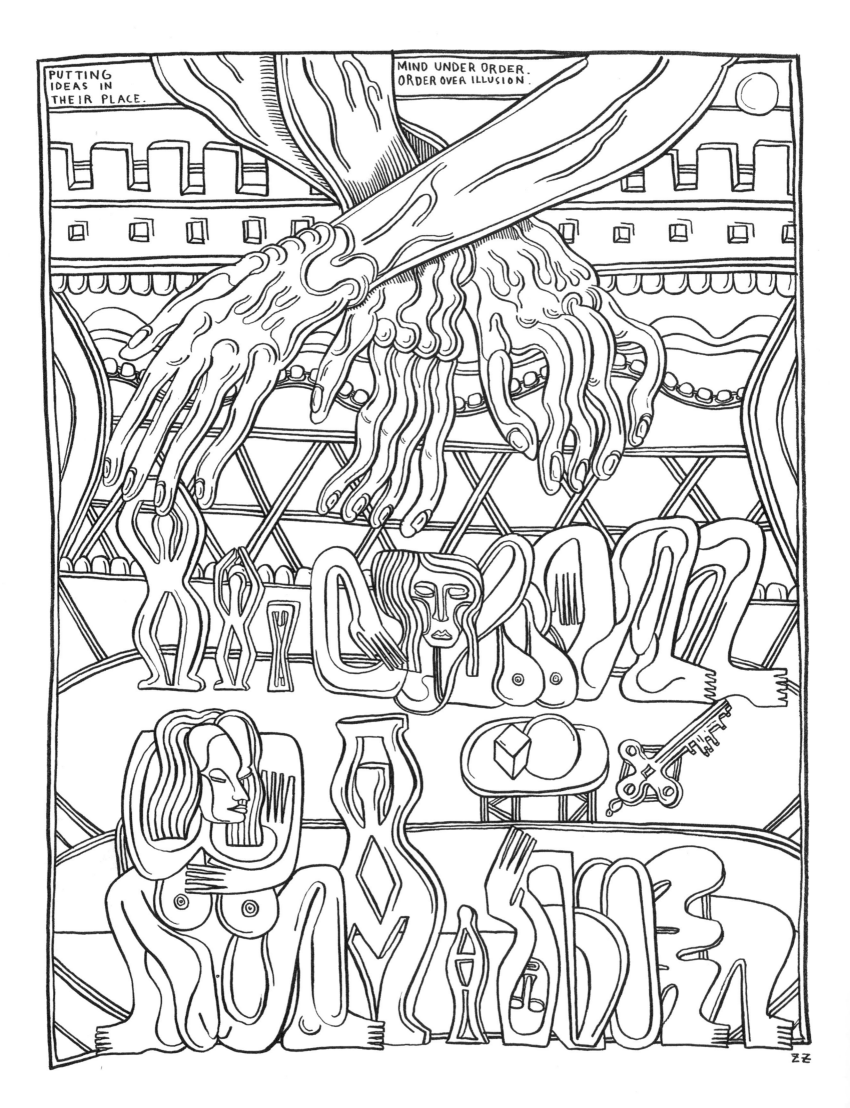

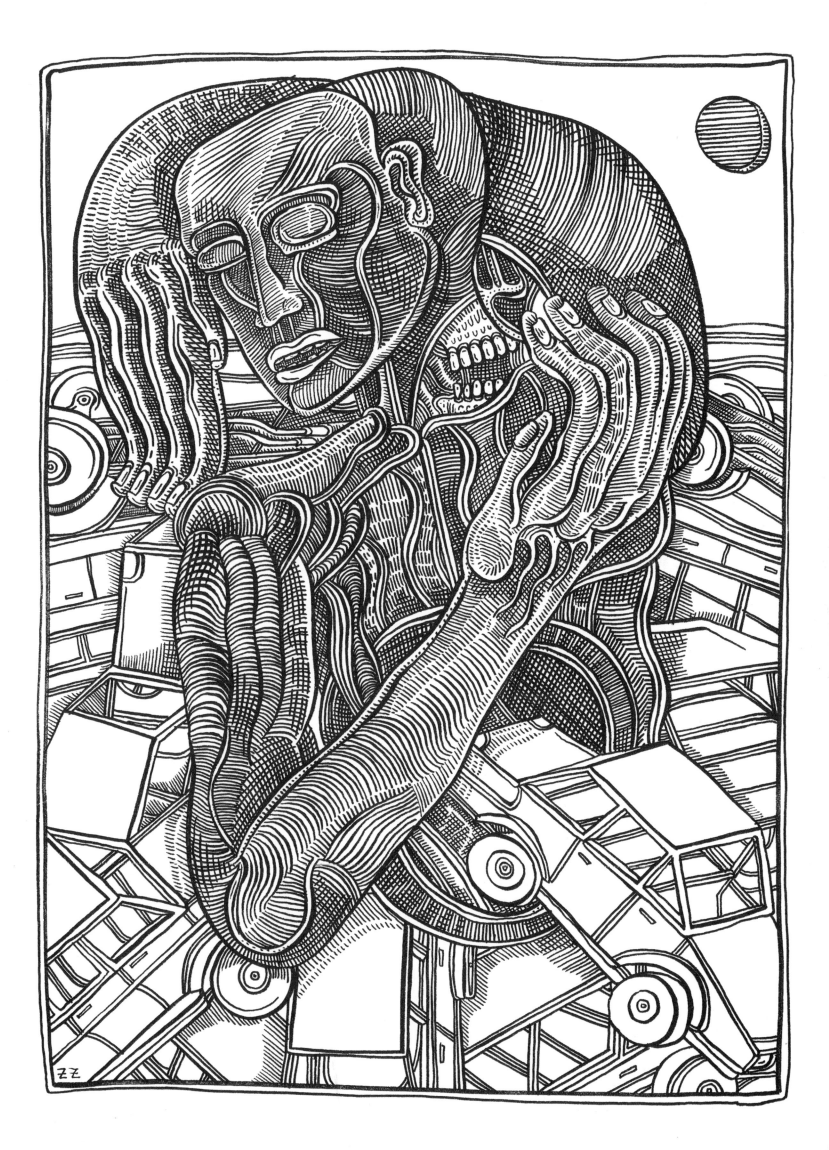

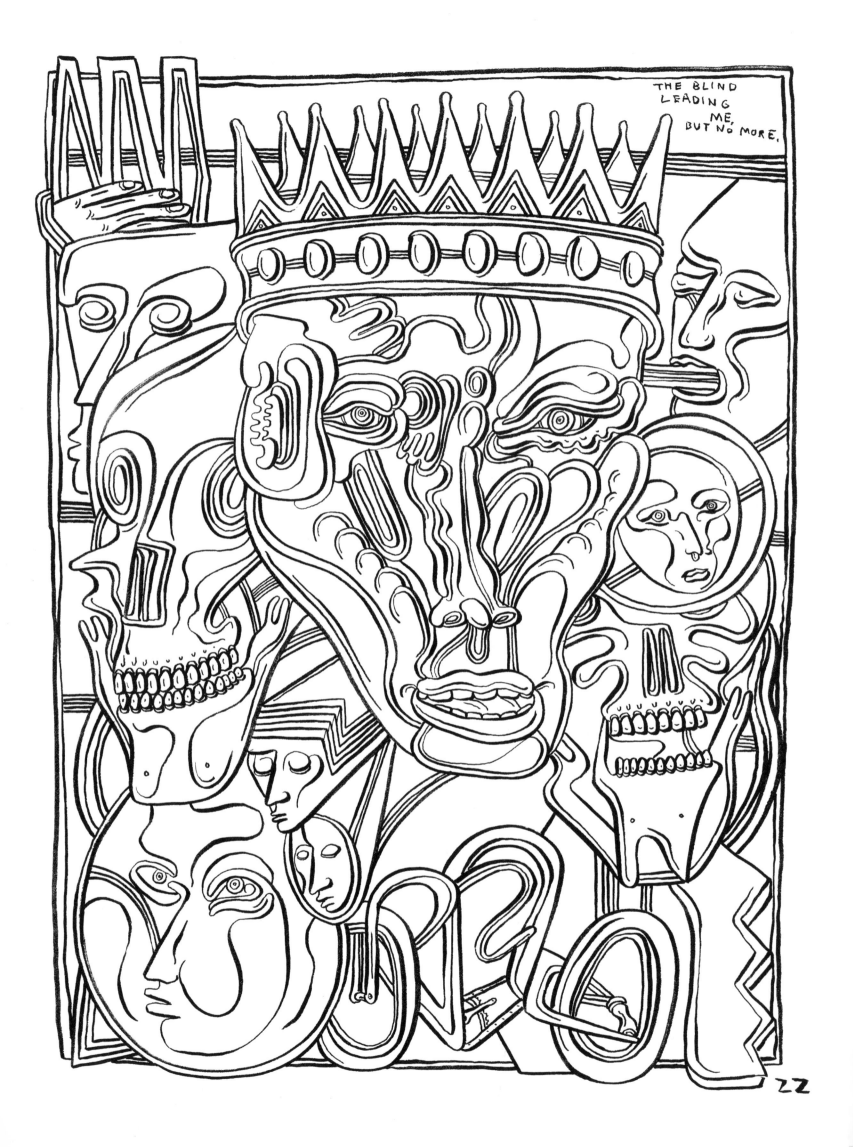

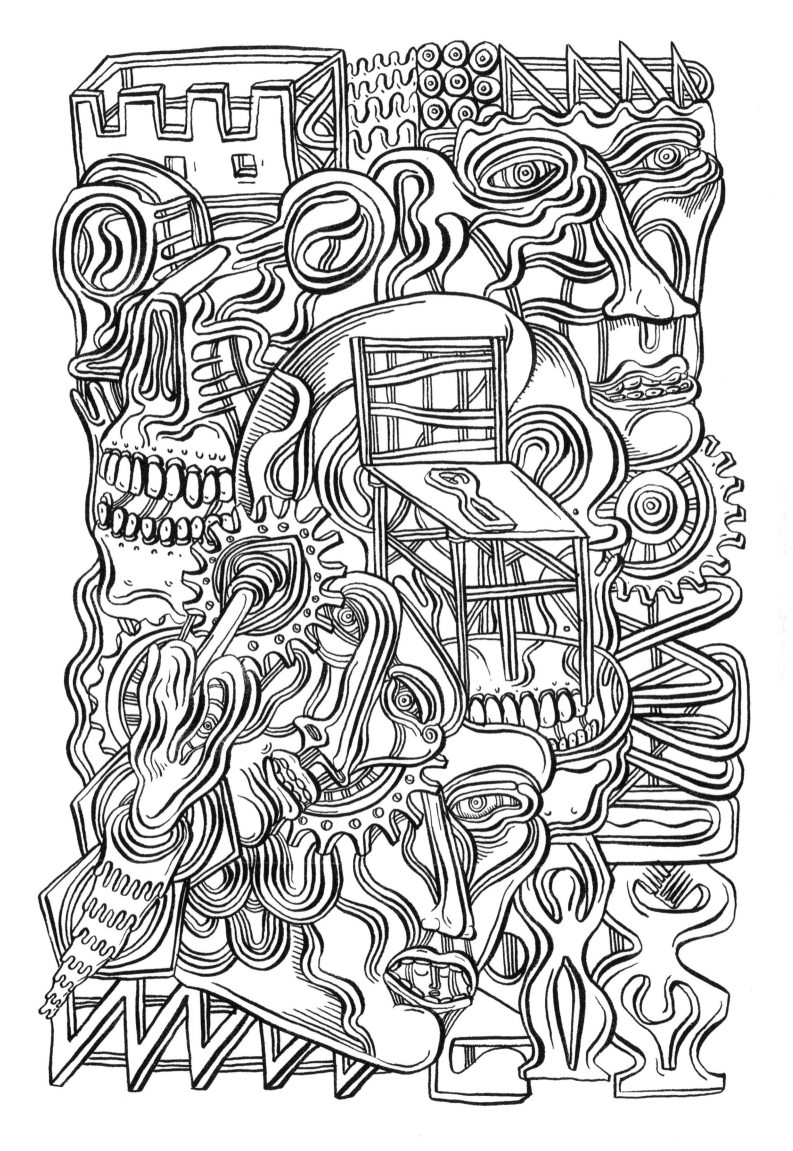

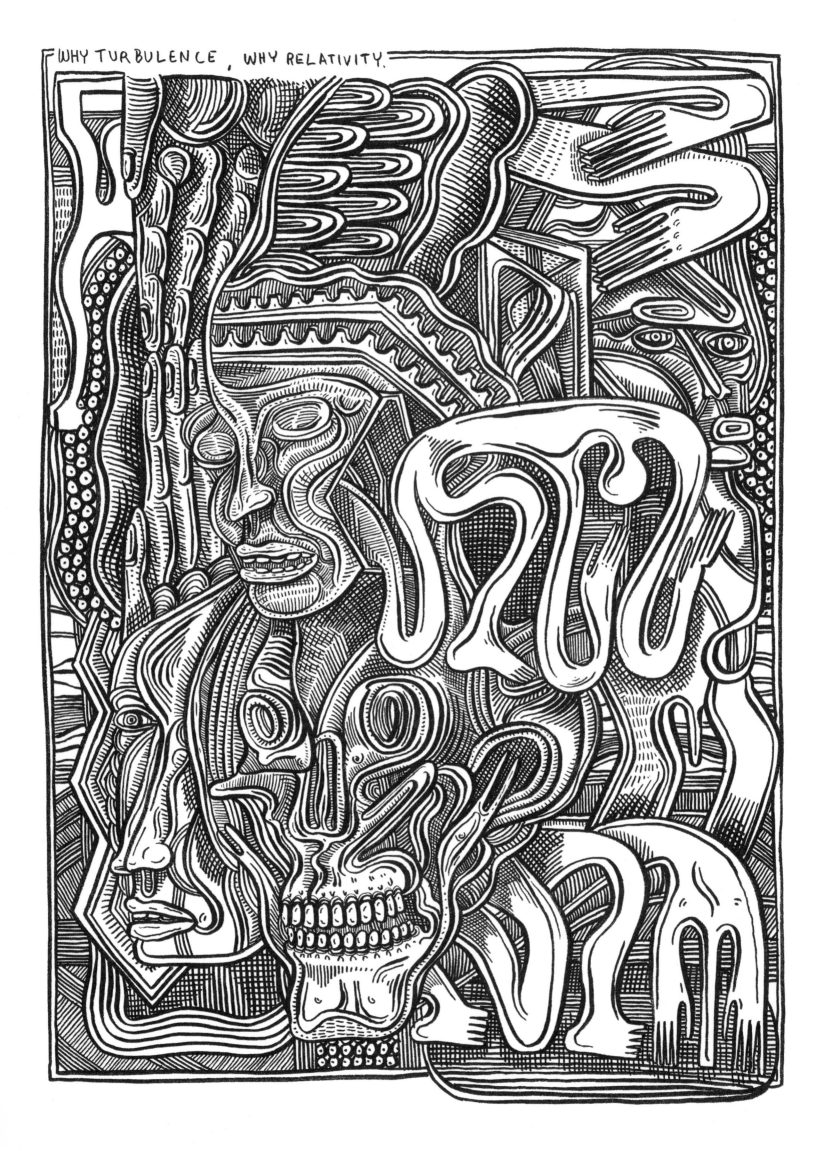

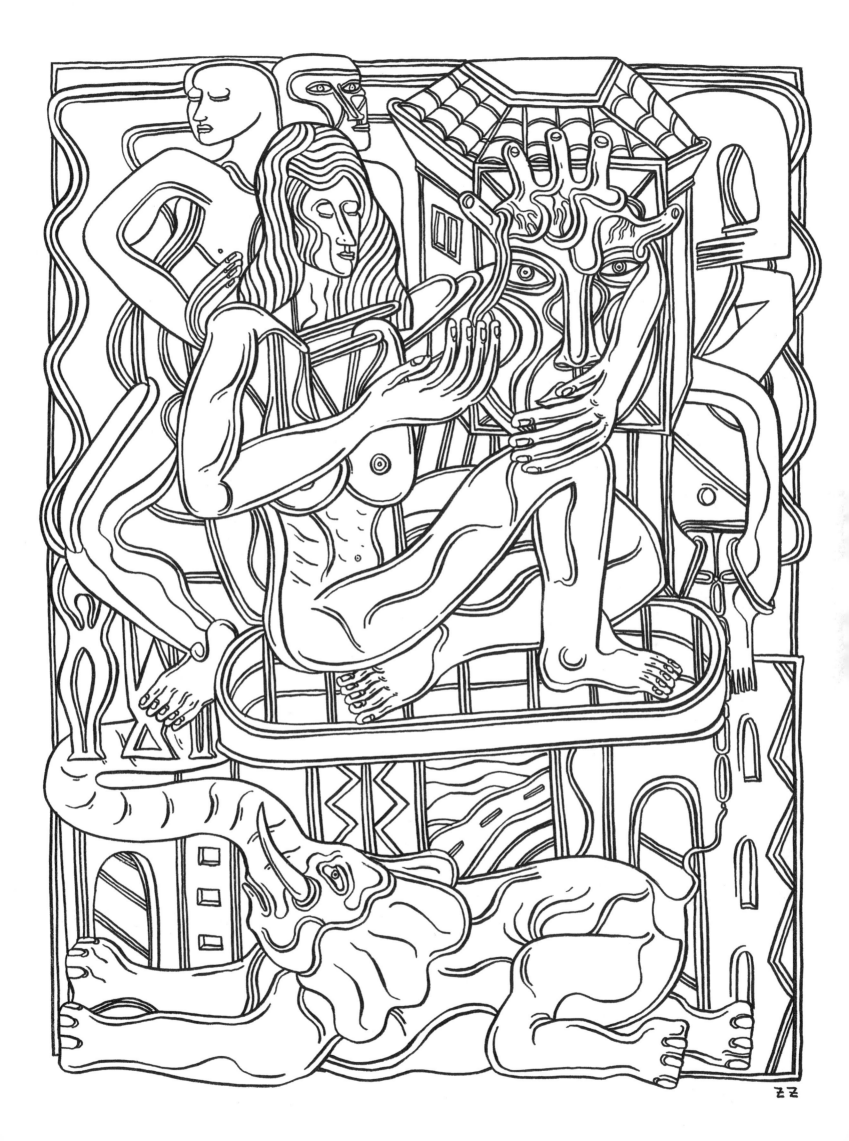

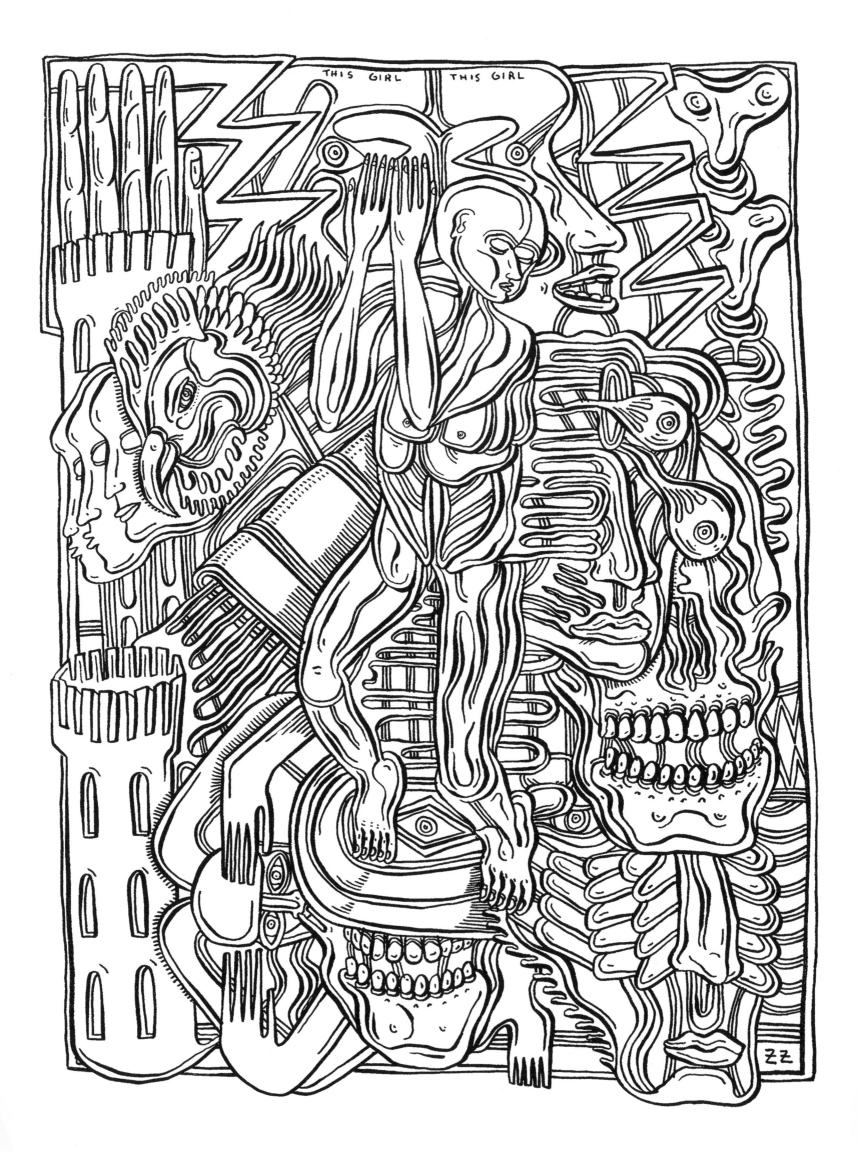

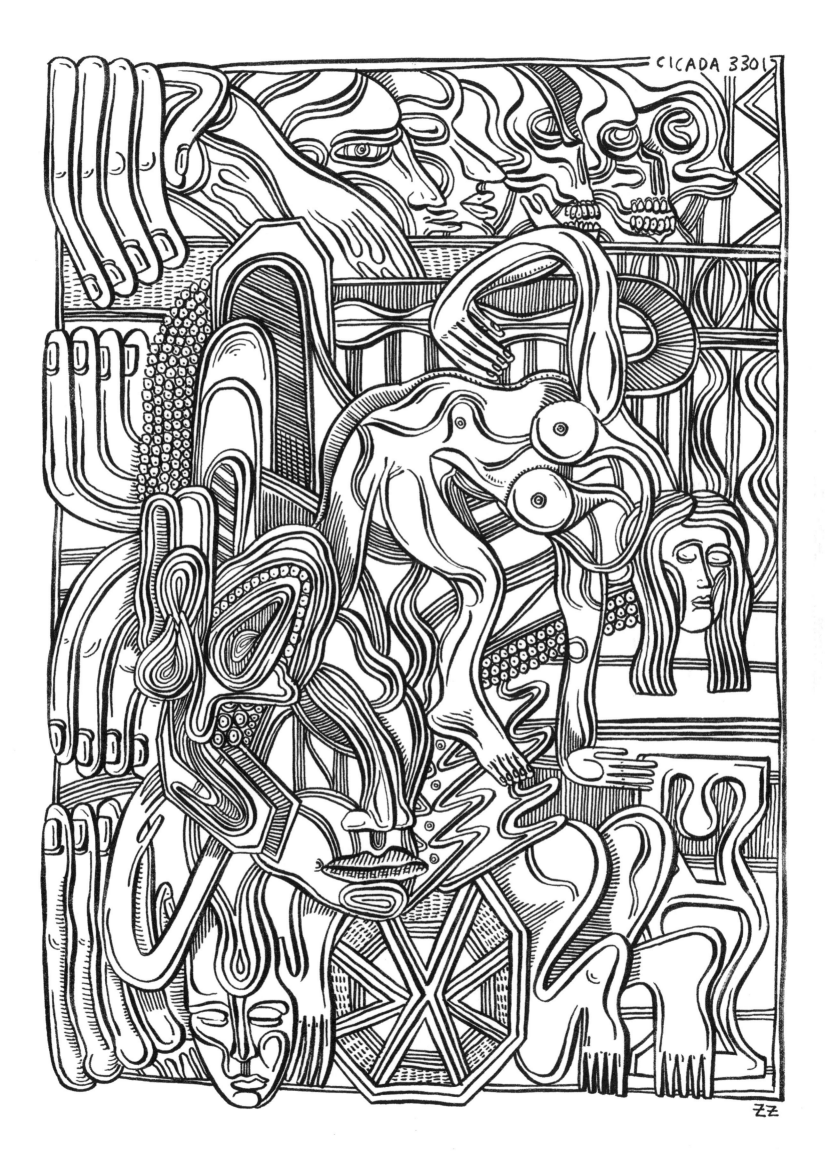

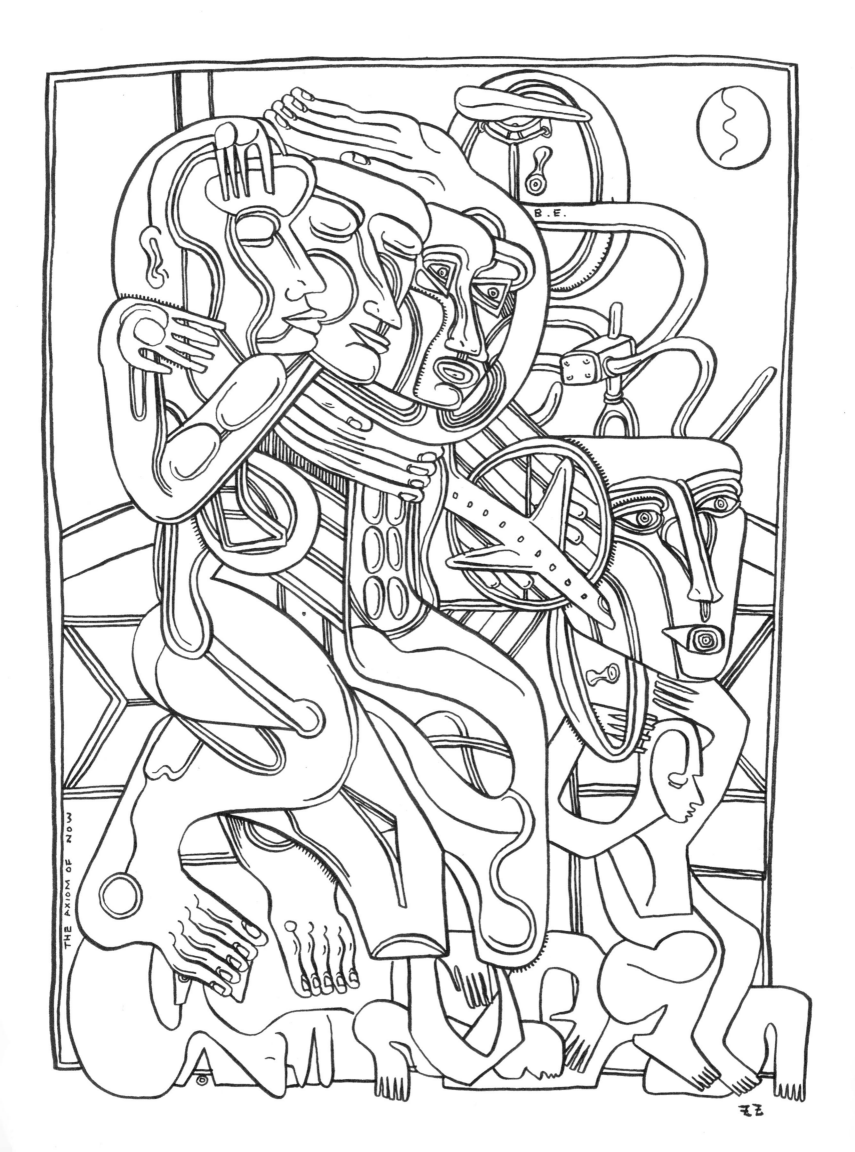

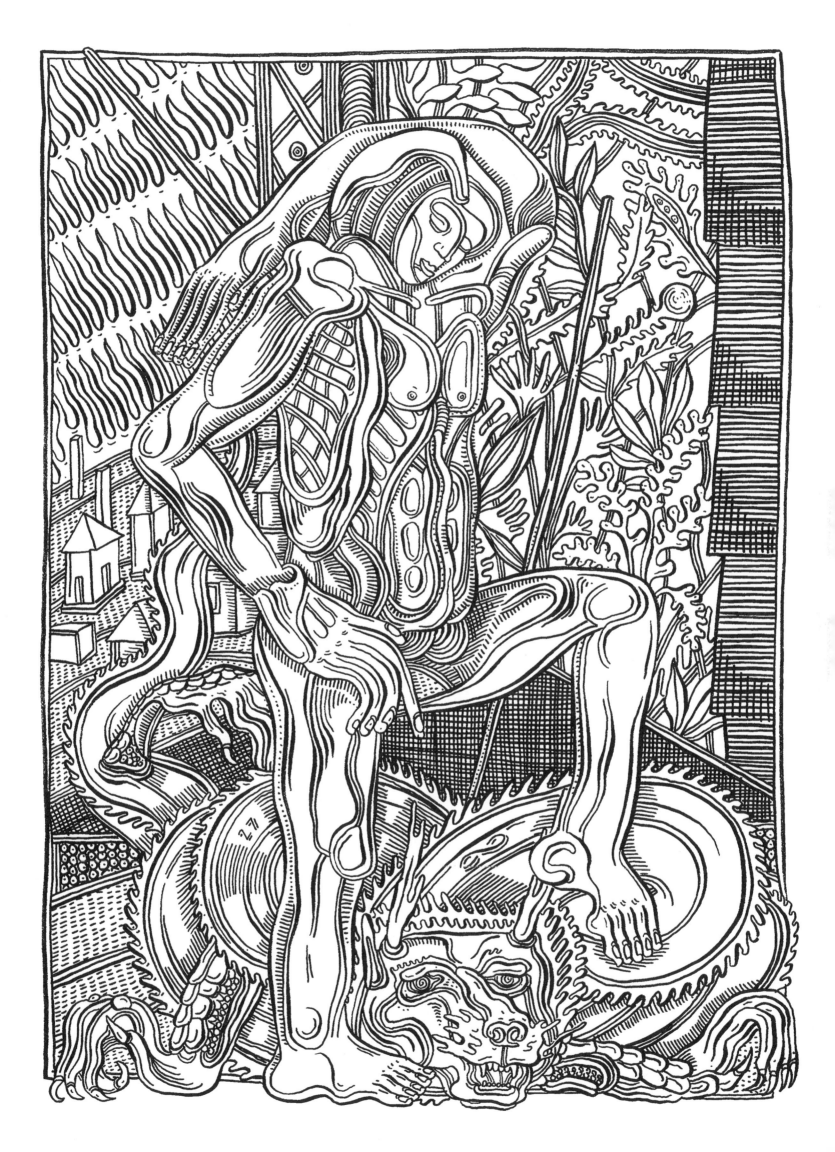

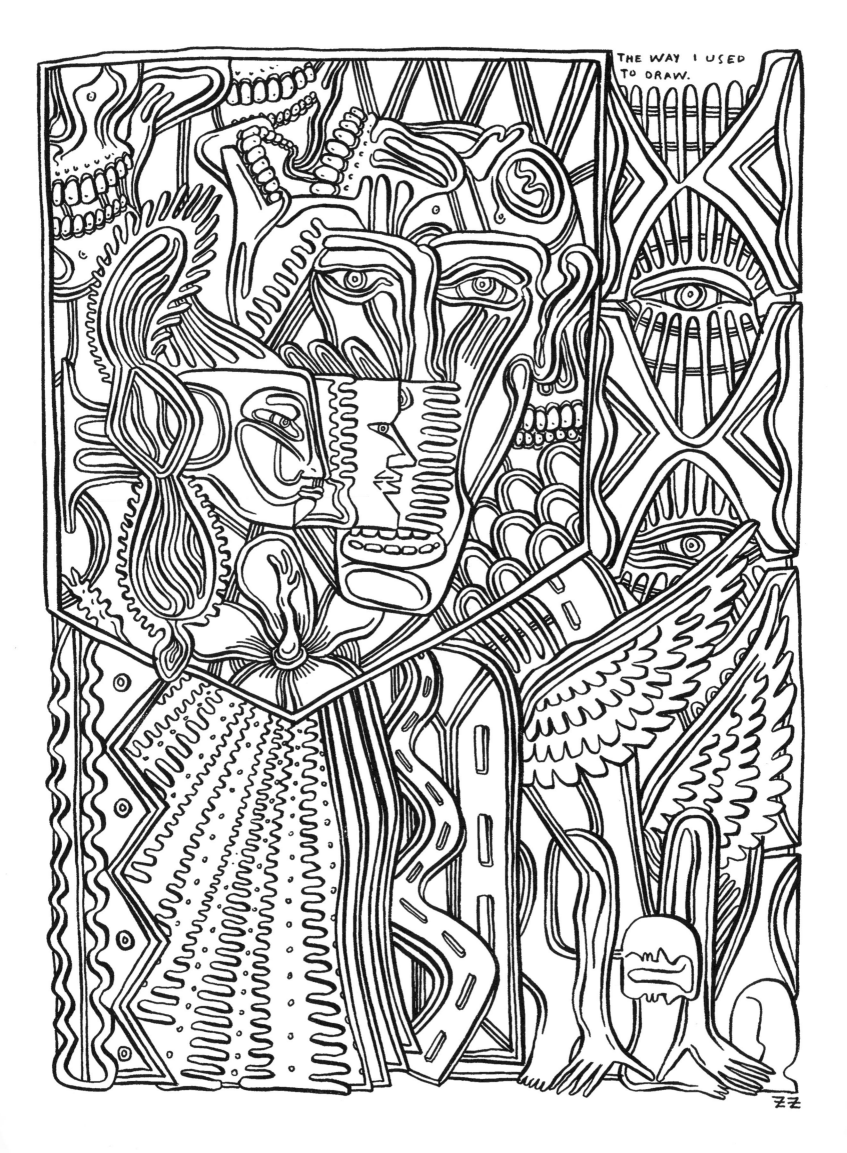

THE WAY I USED TO DRAW.

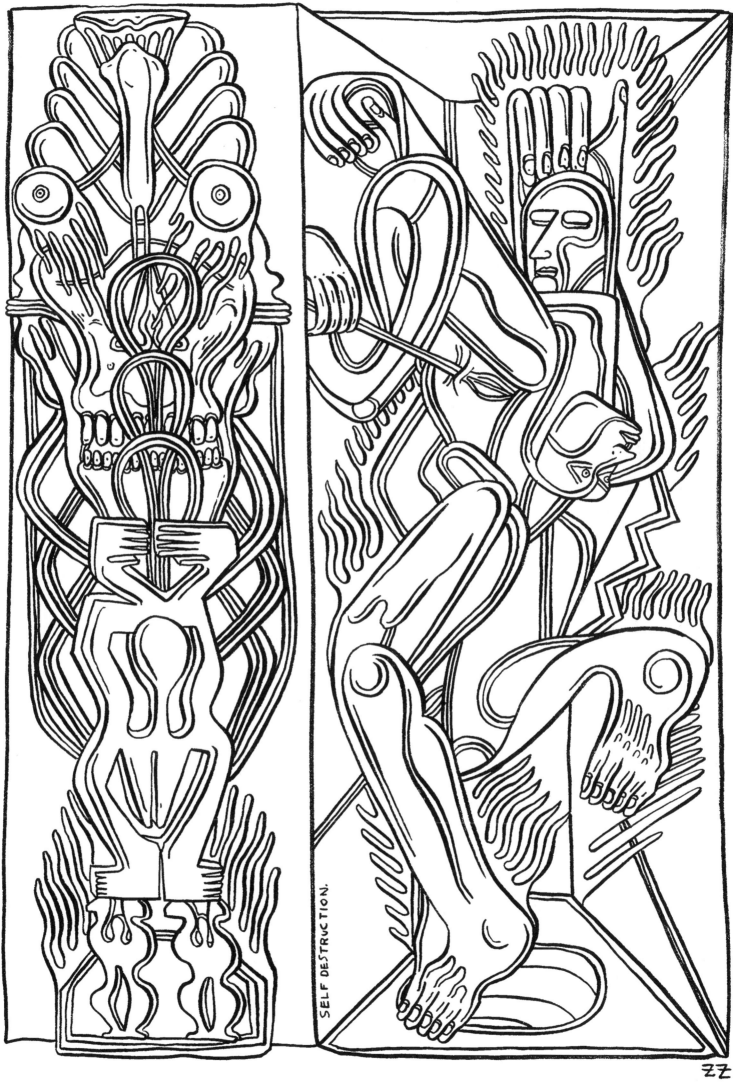

SELF DESTRUCTION.

ZZ

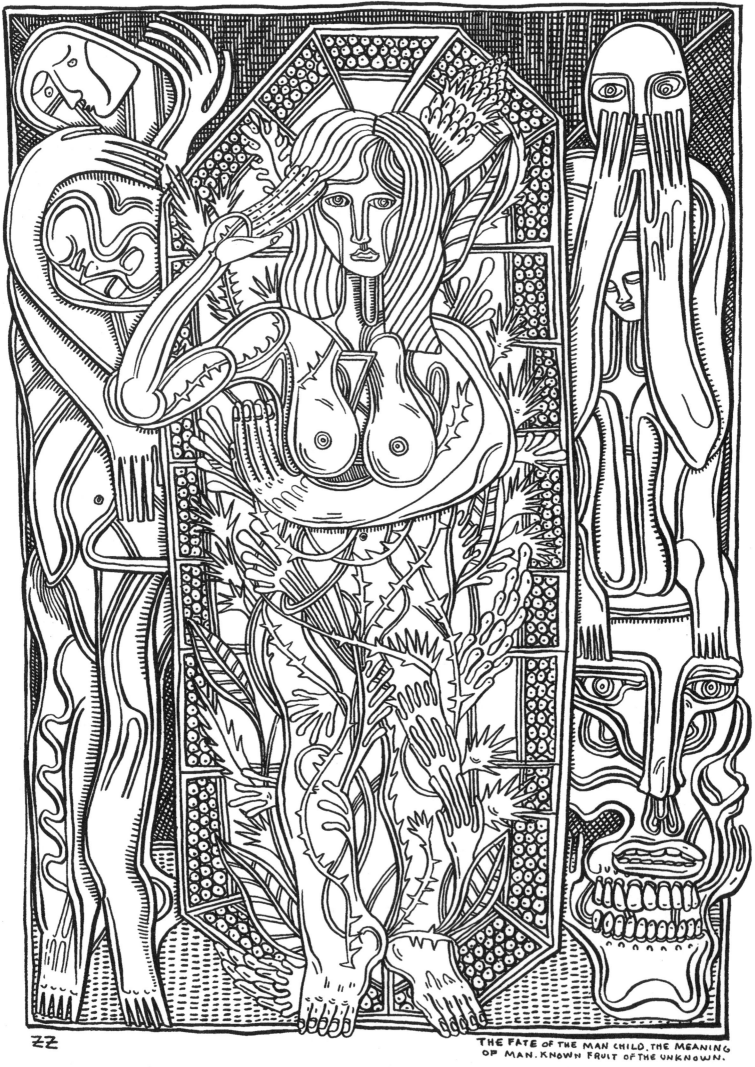

ZZ

THE FATE OF THE MAN CHILD. THE MEANING
OF MAN. KNOWN FRUIT OF THE UNKNOWN.

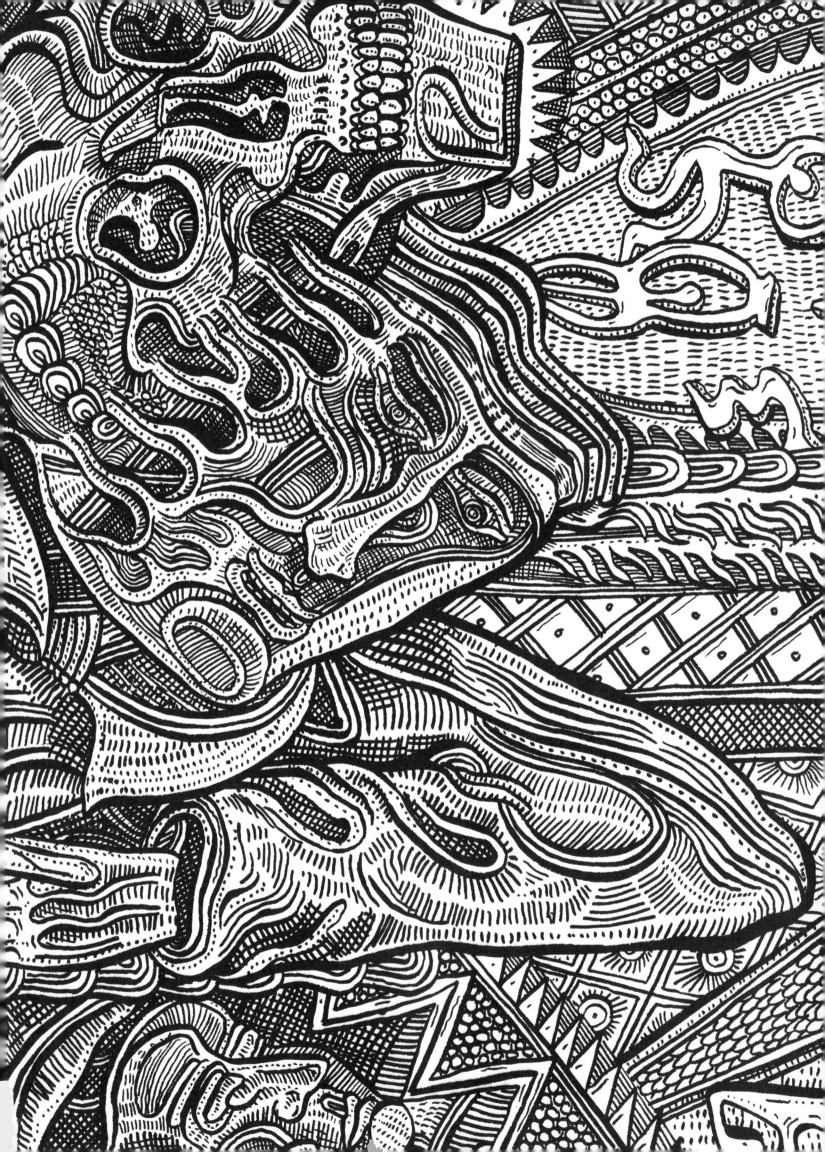

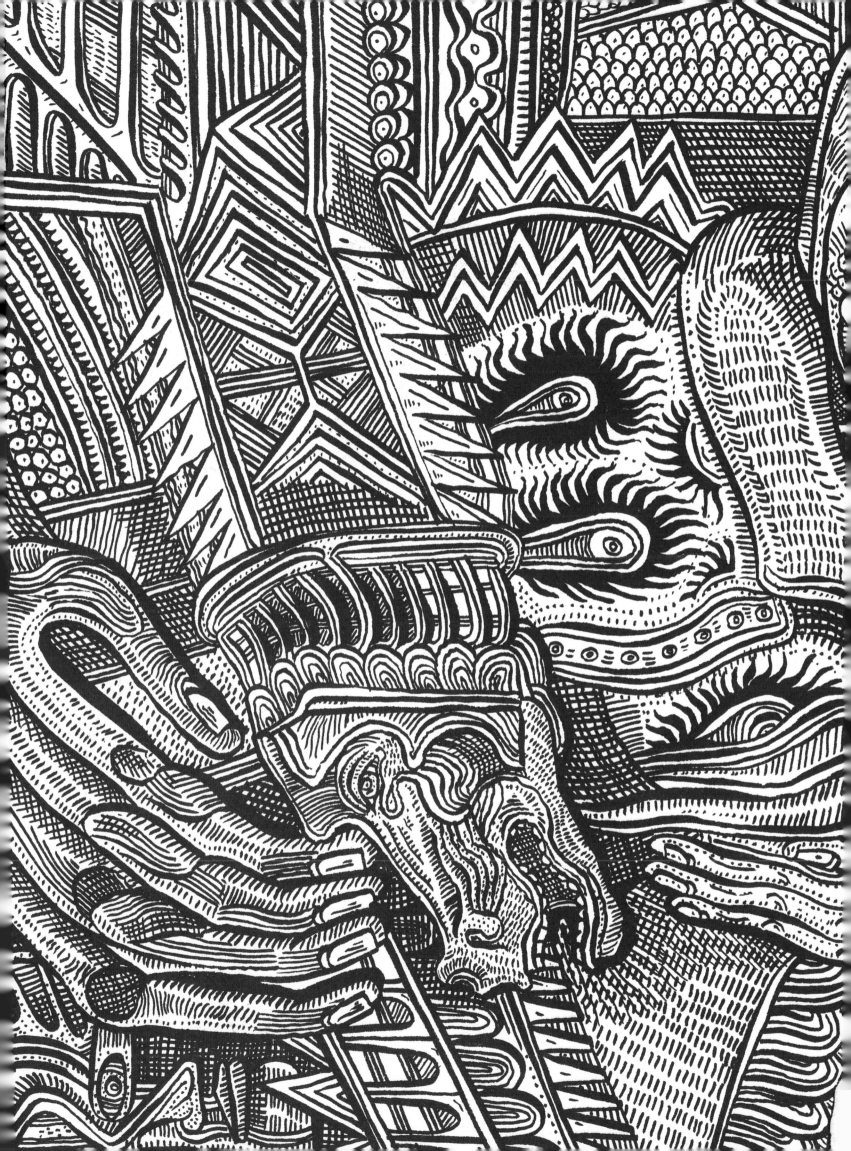

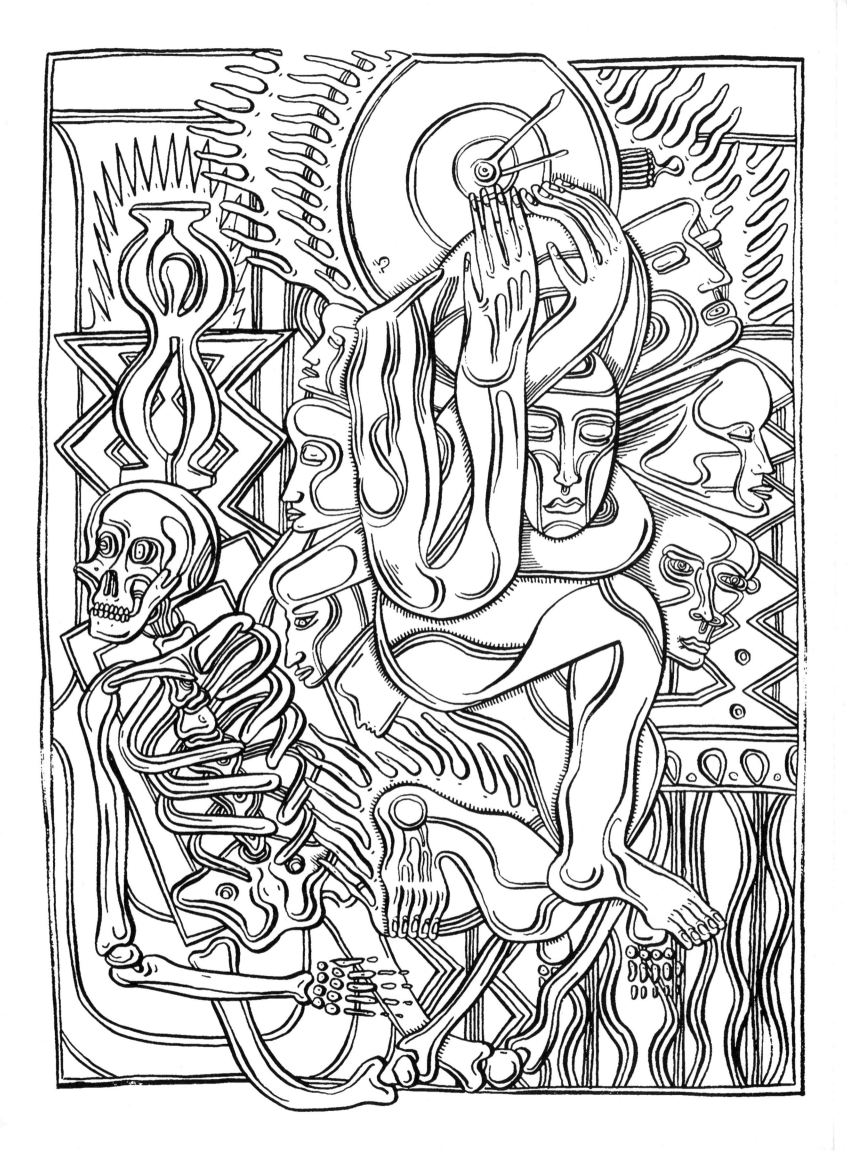

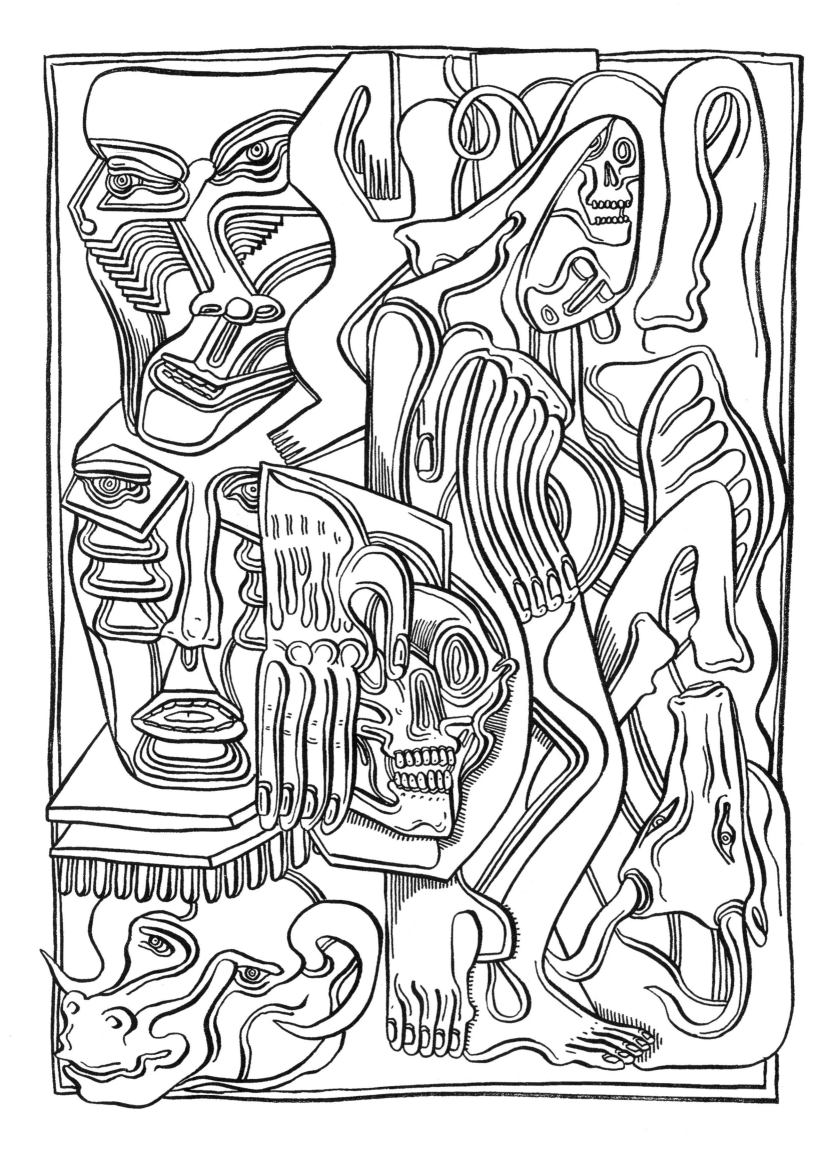

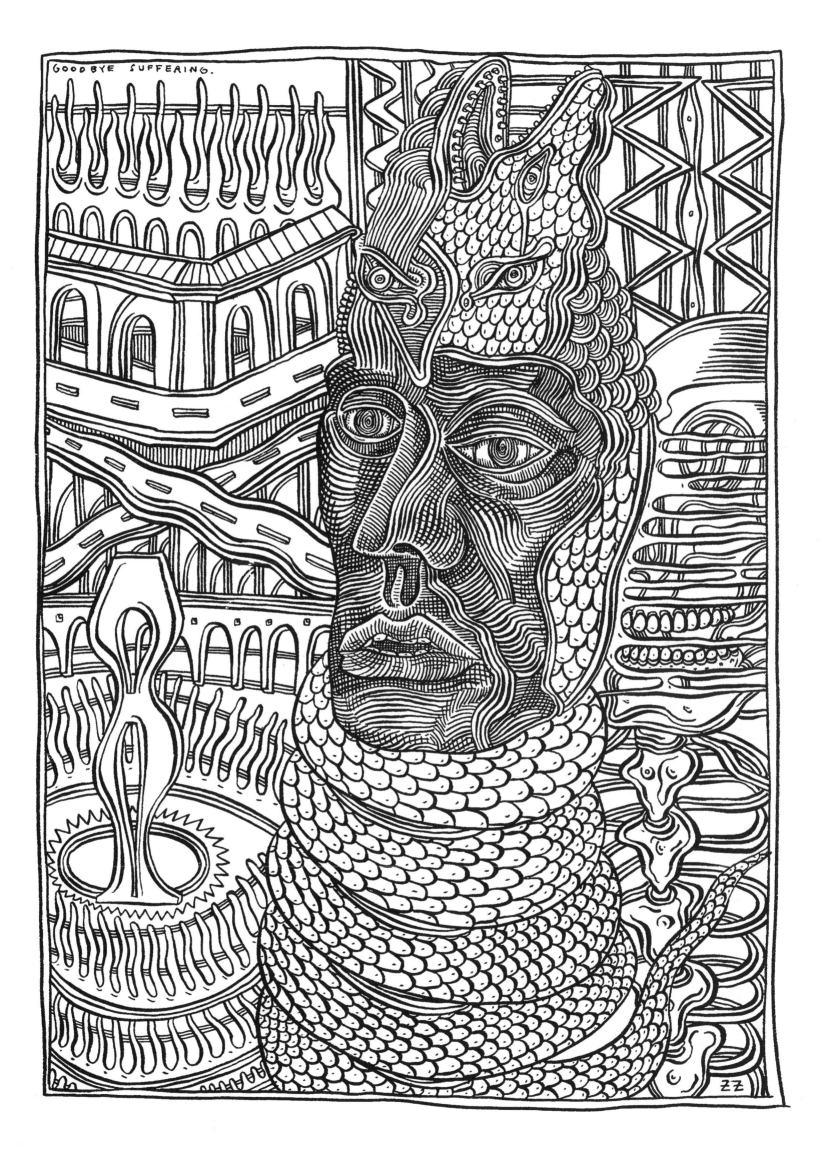

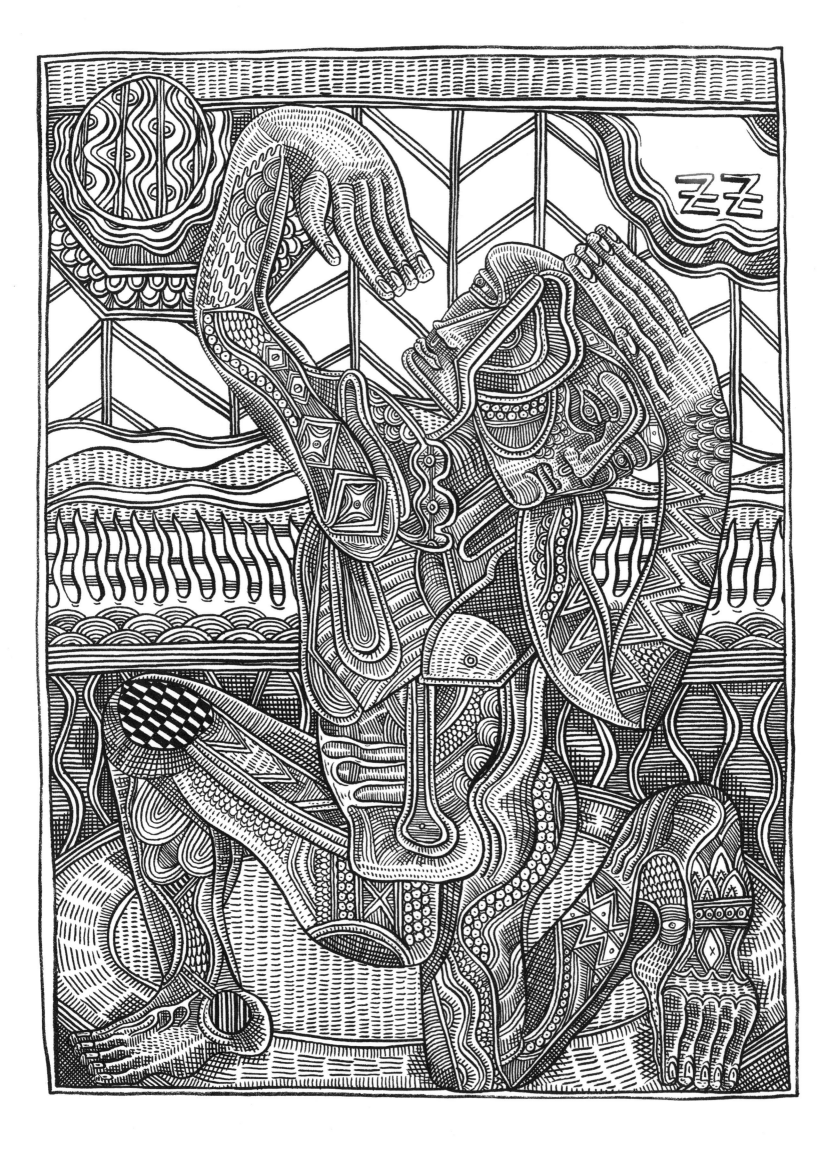

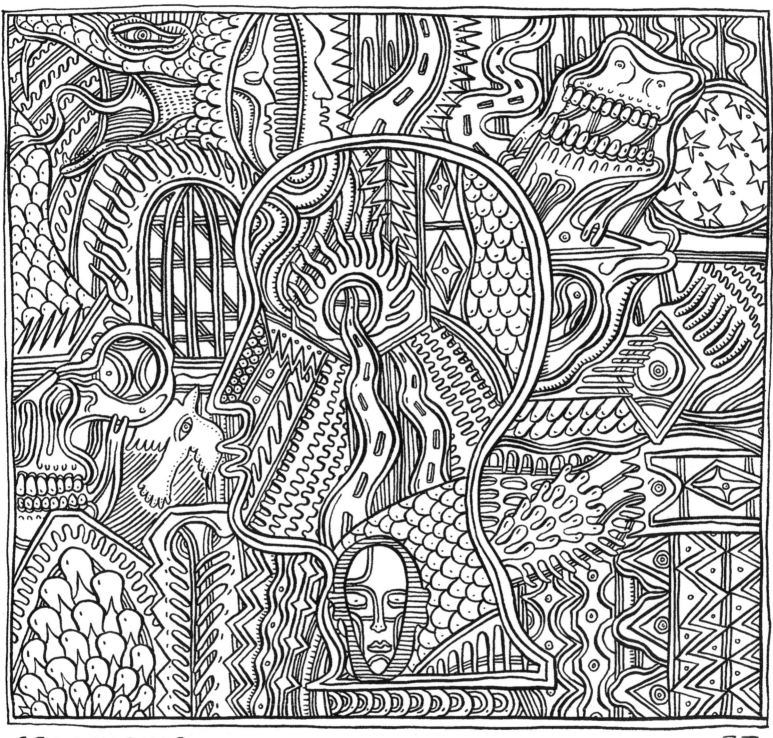

GEOGRAPHER ZZ

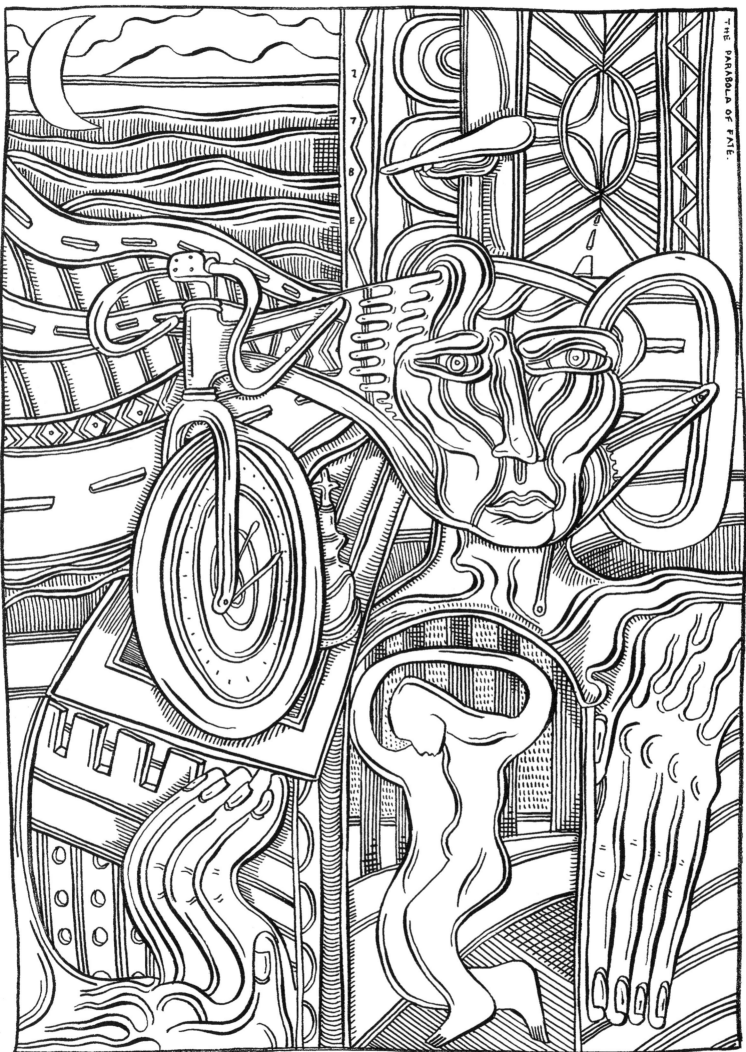

THE PARABOLA OF FATE.

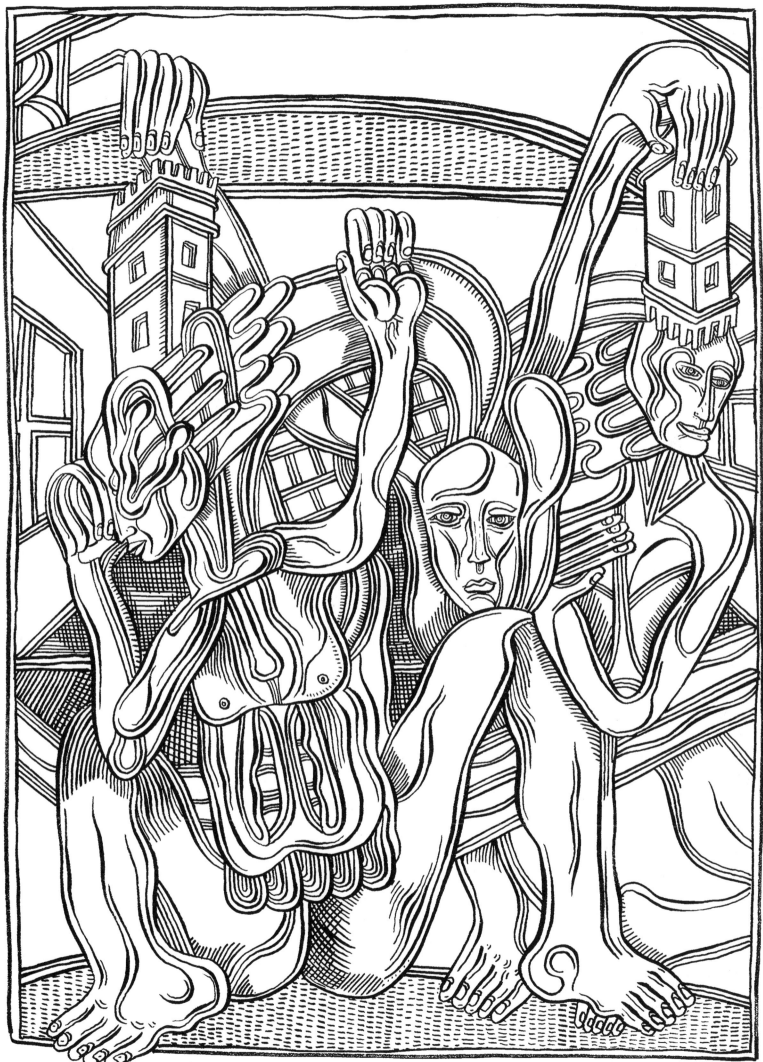

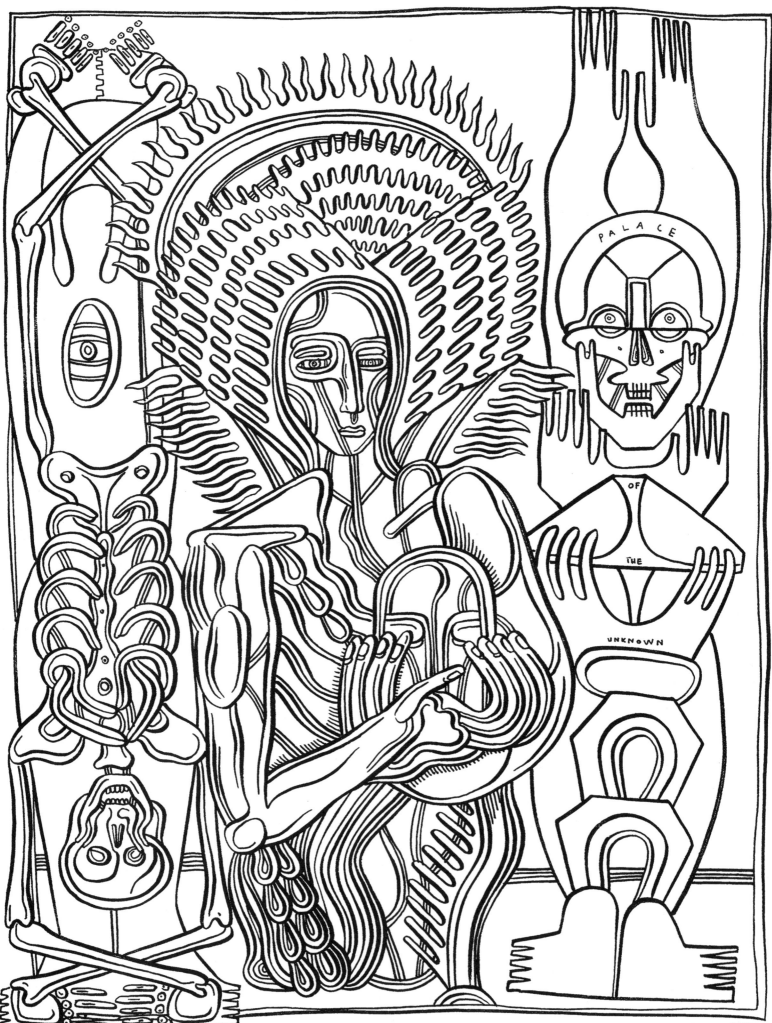

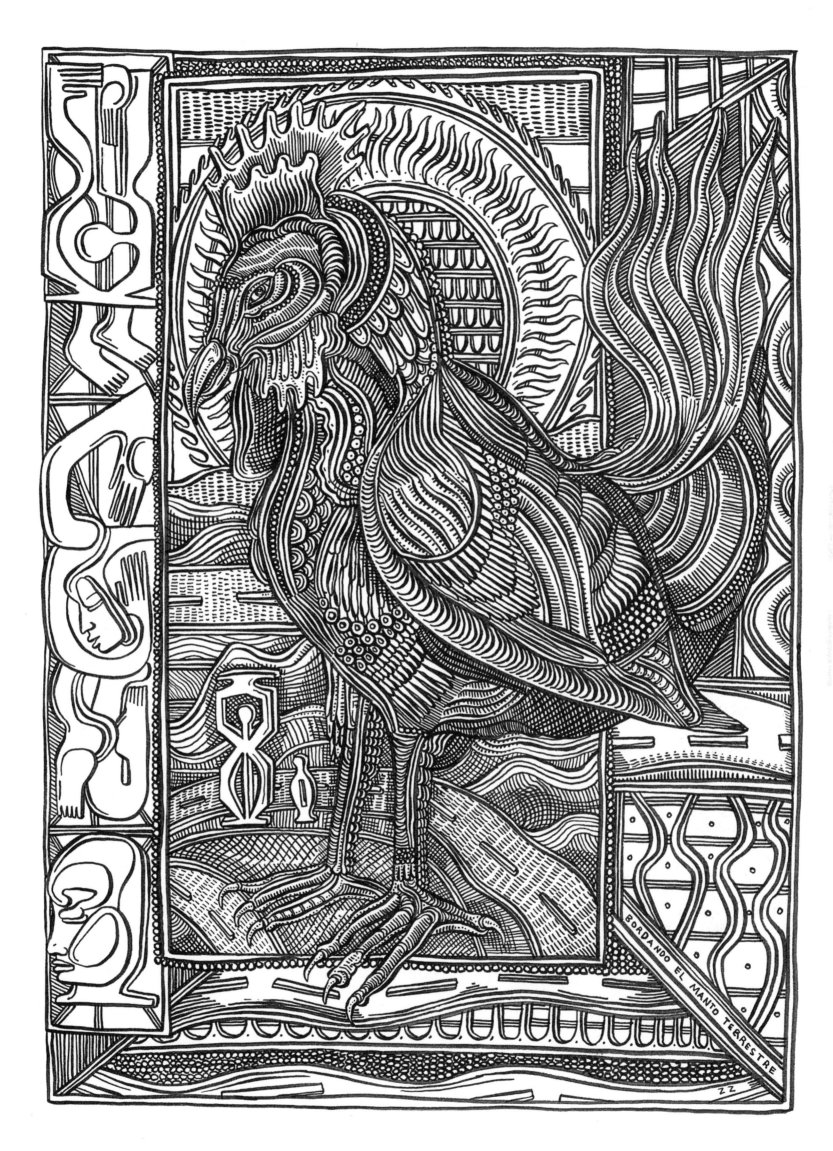

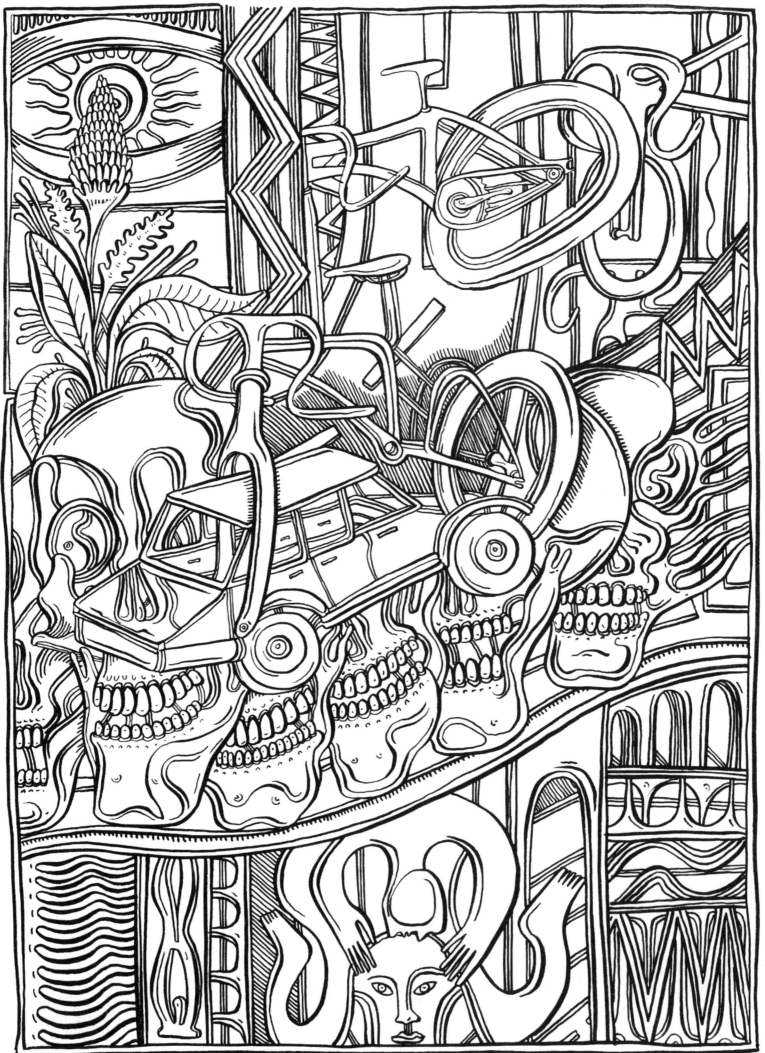

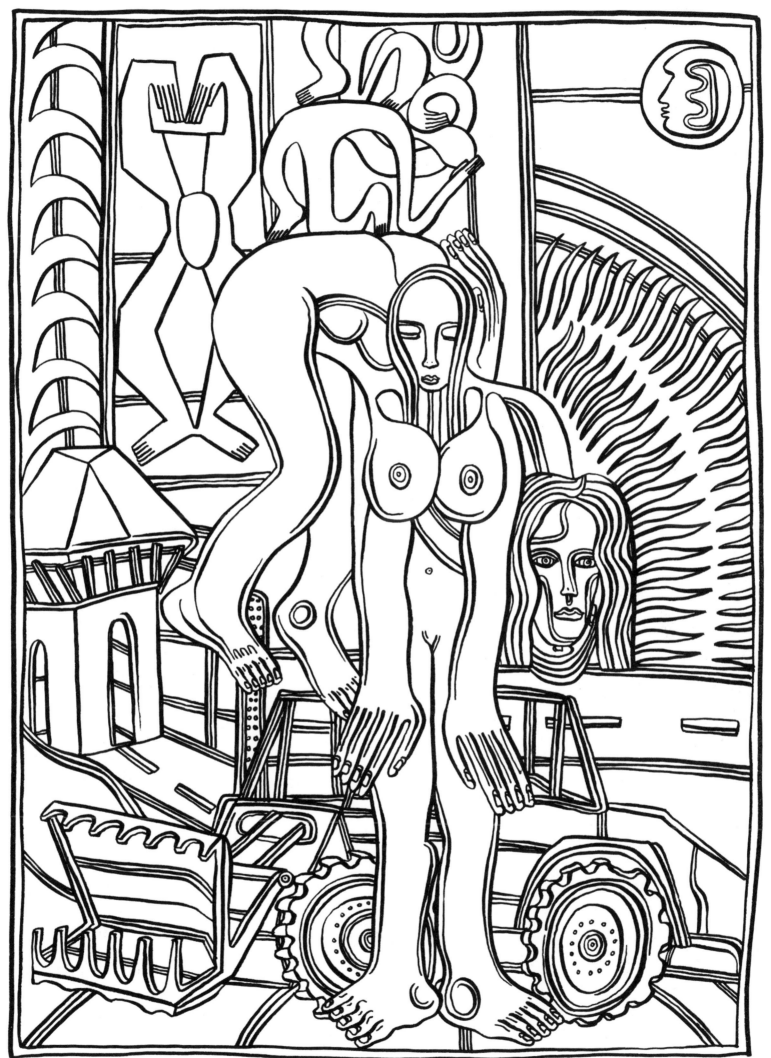

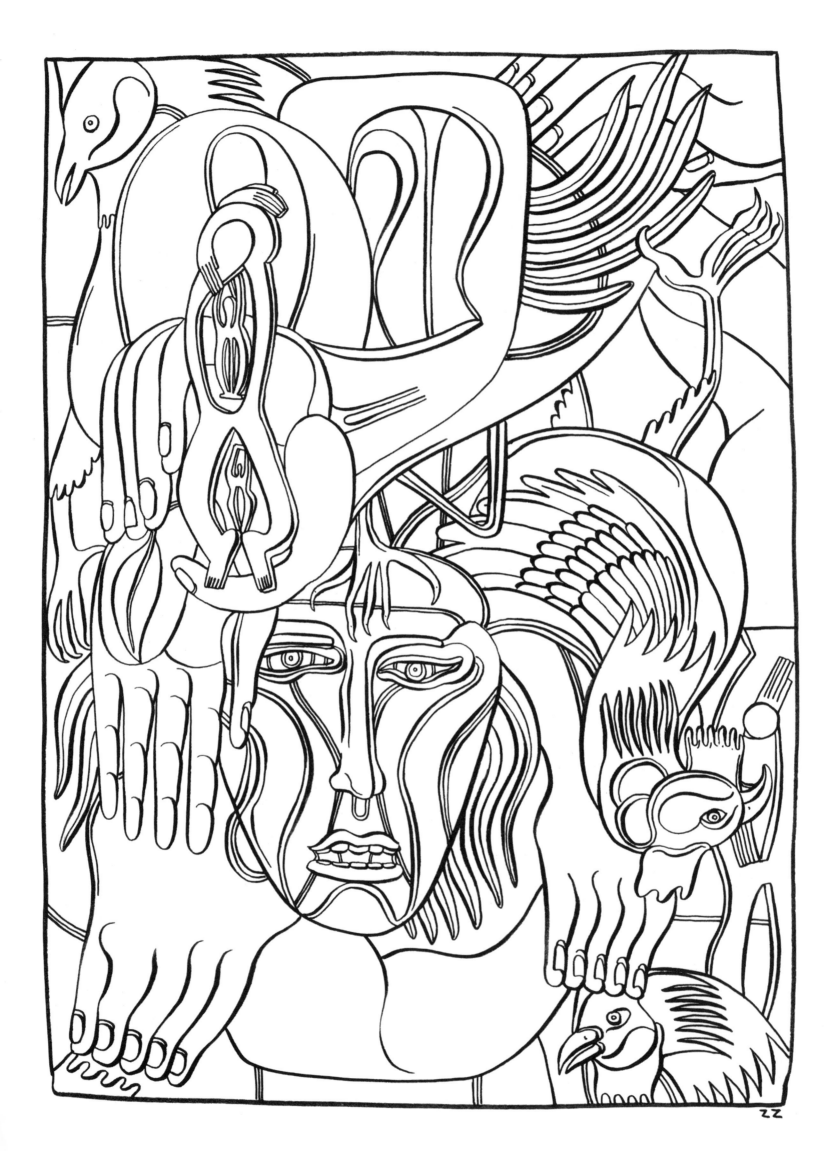

22

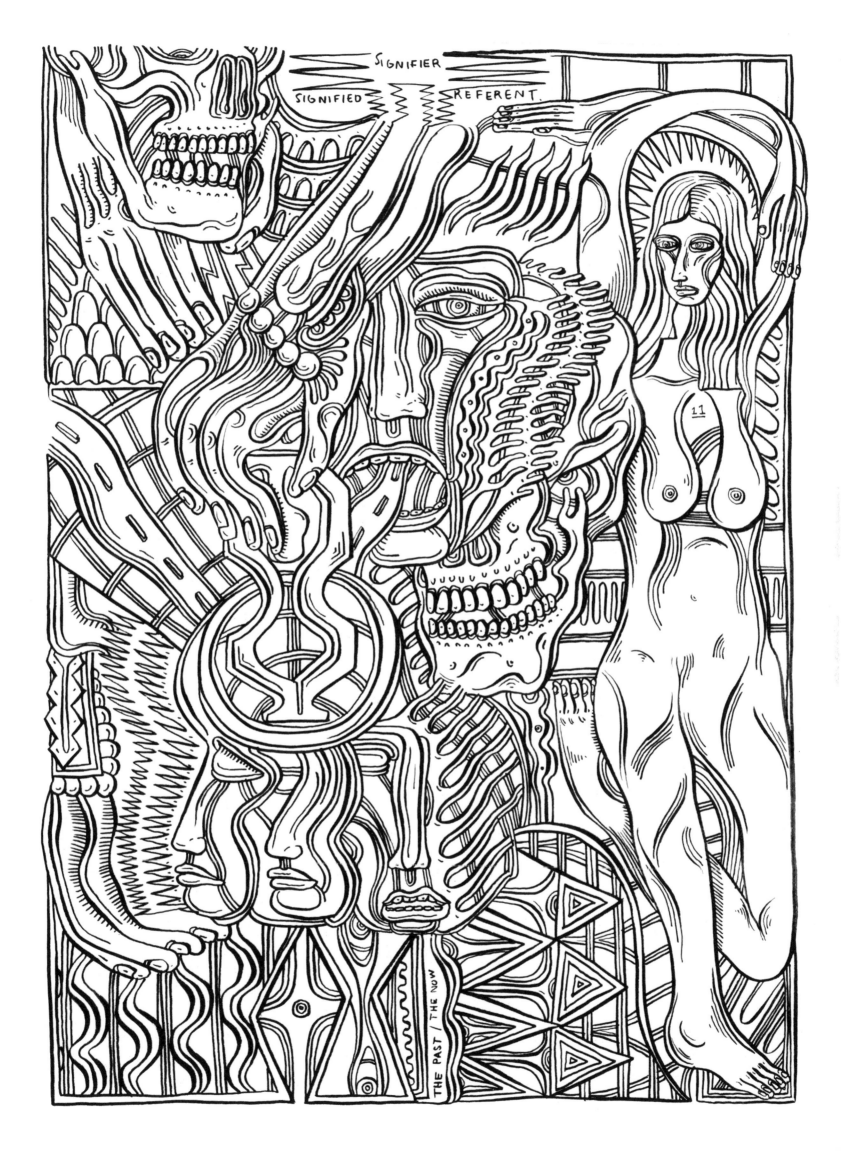

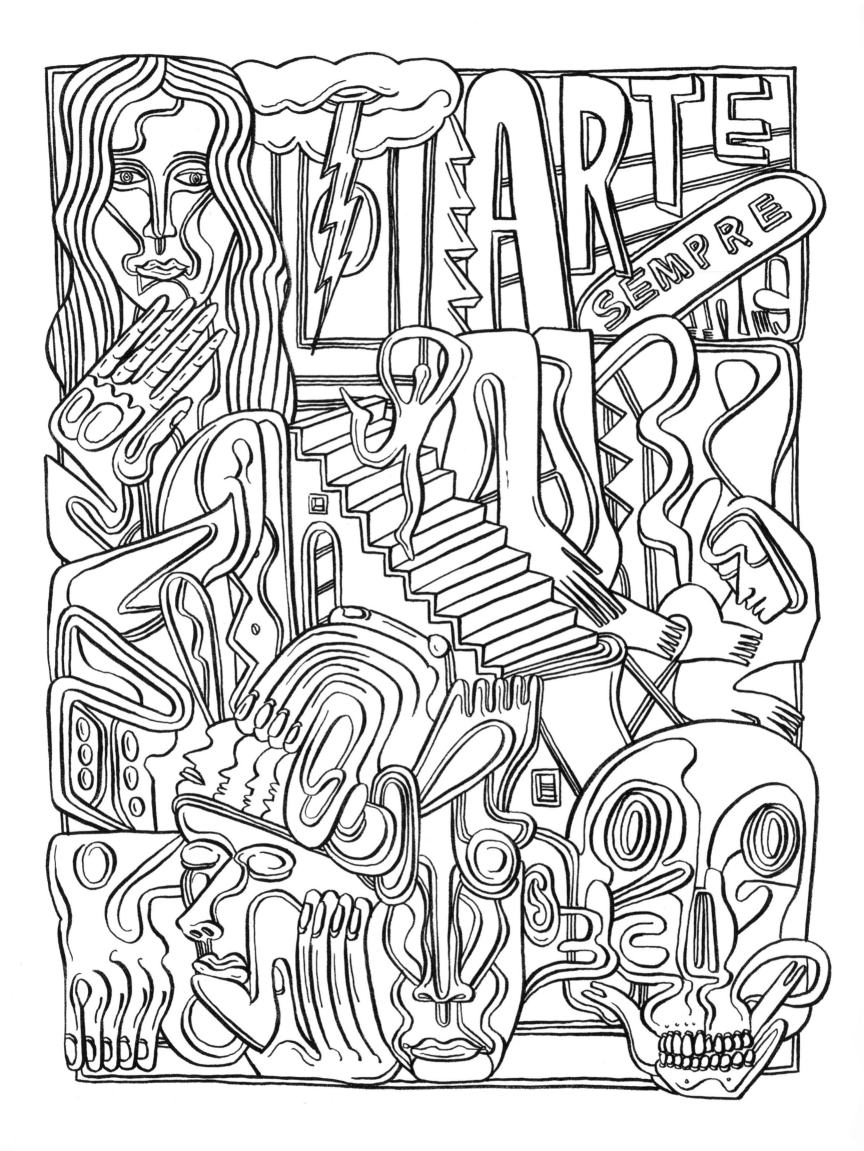

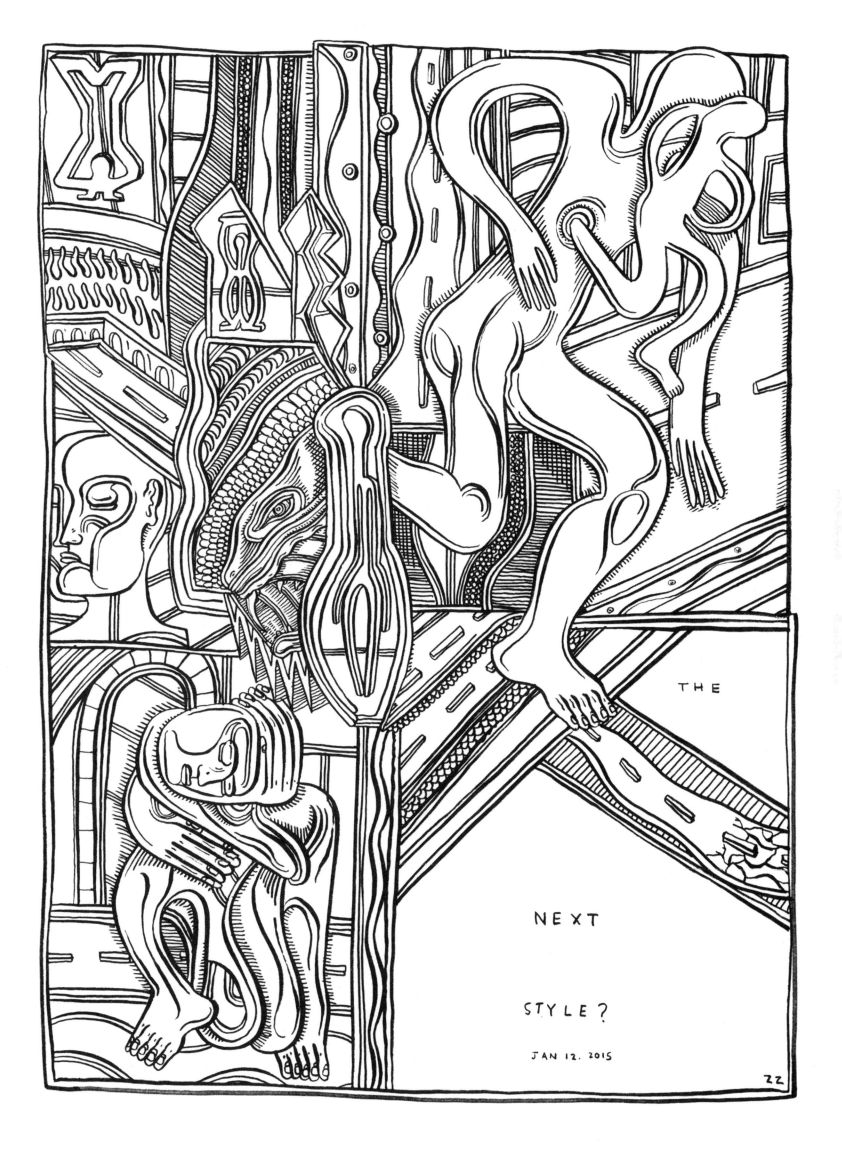

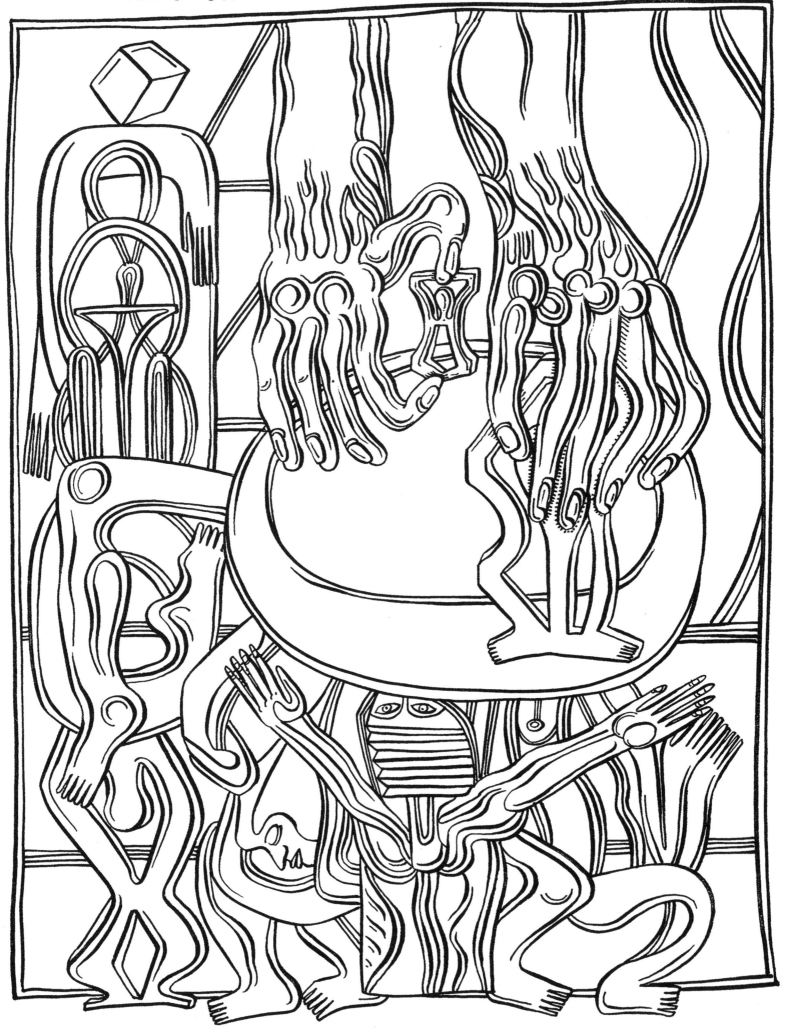

THE UNCONSCIOUS GOD

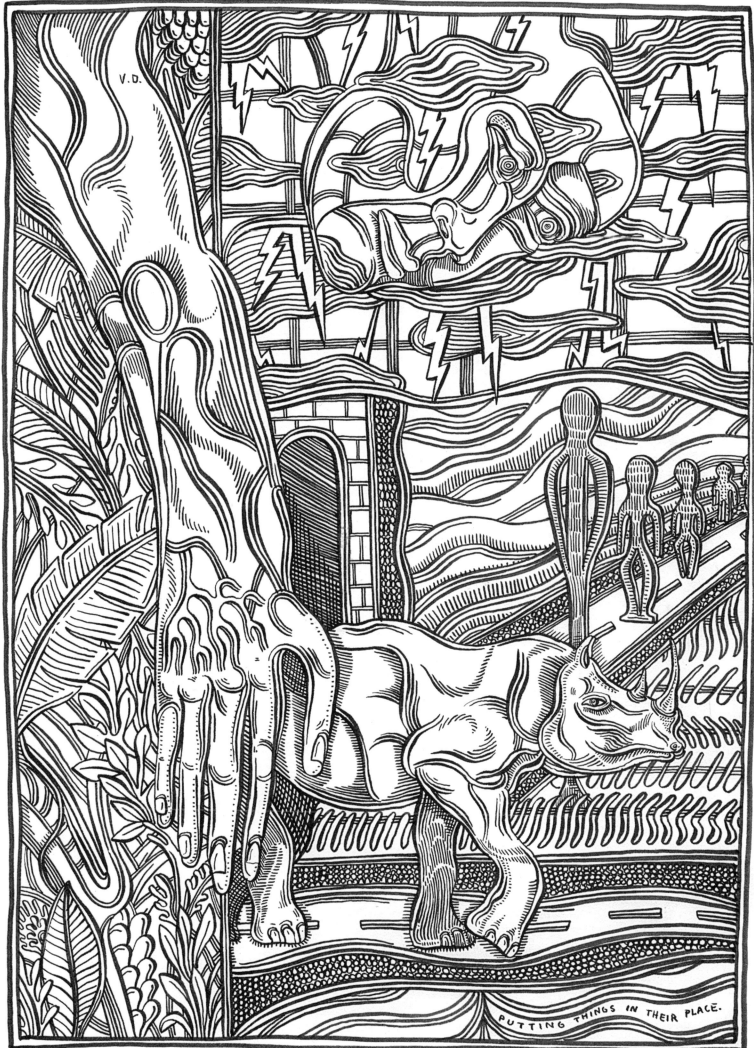

PUTTING THINGS IN THEIR PLACE.

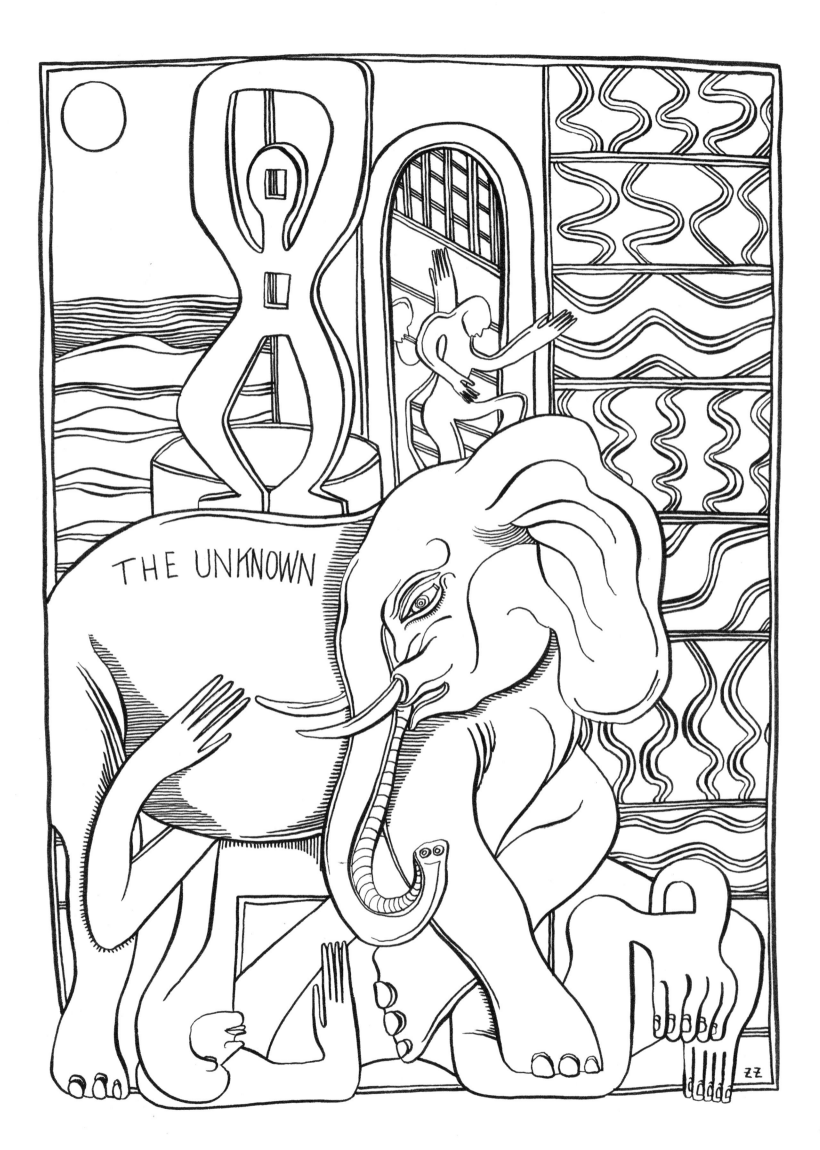

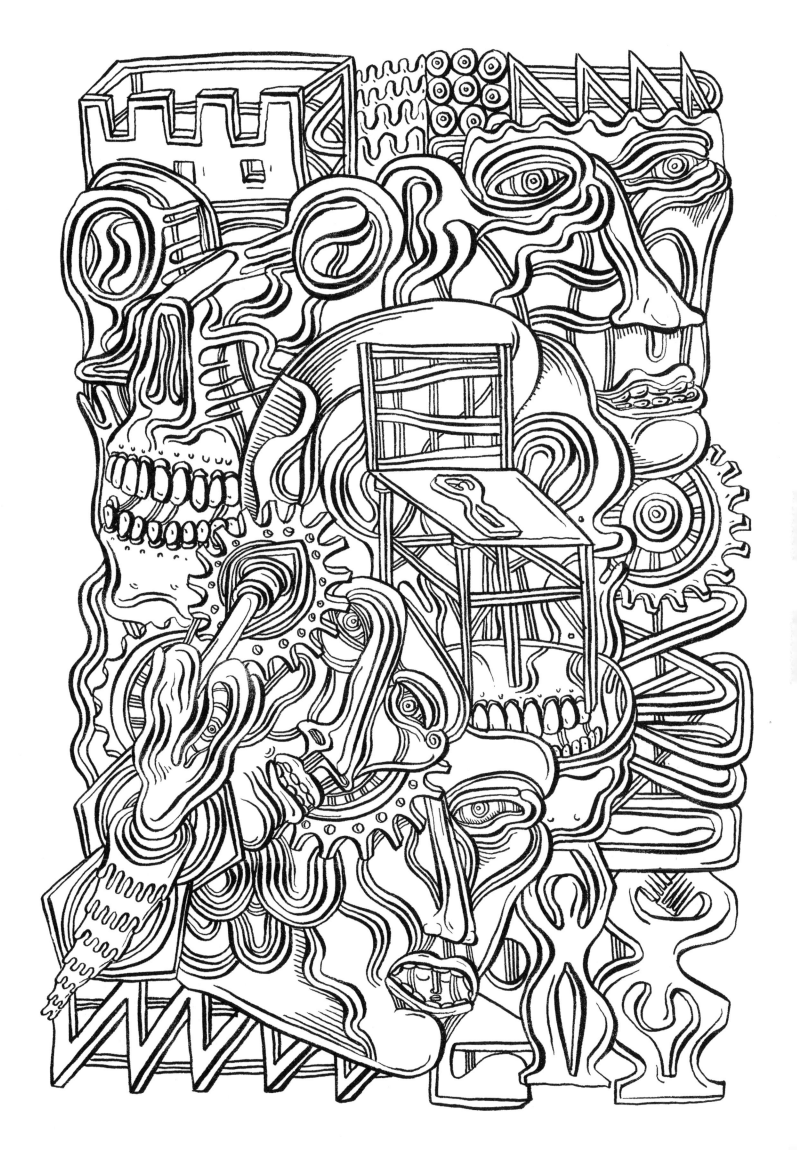

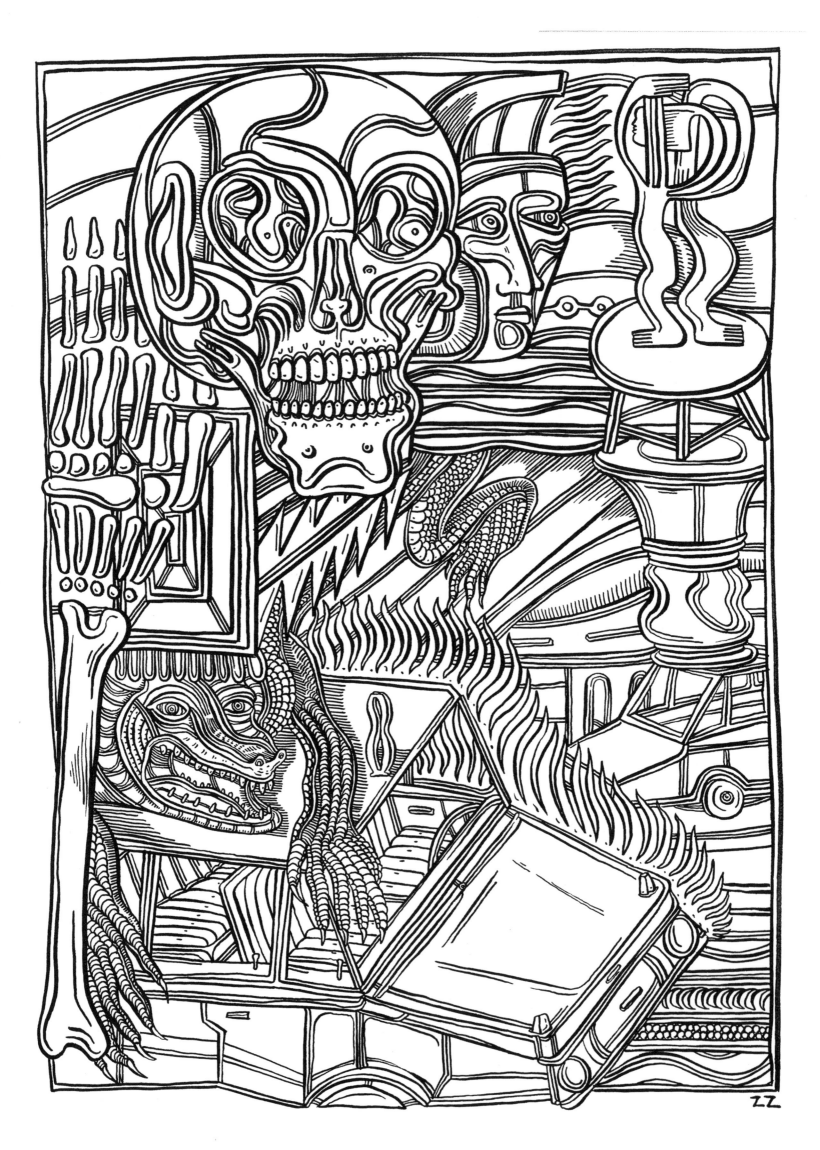

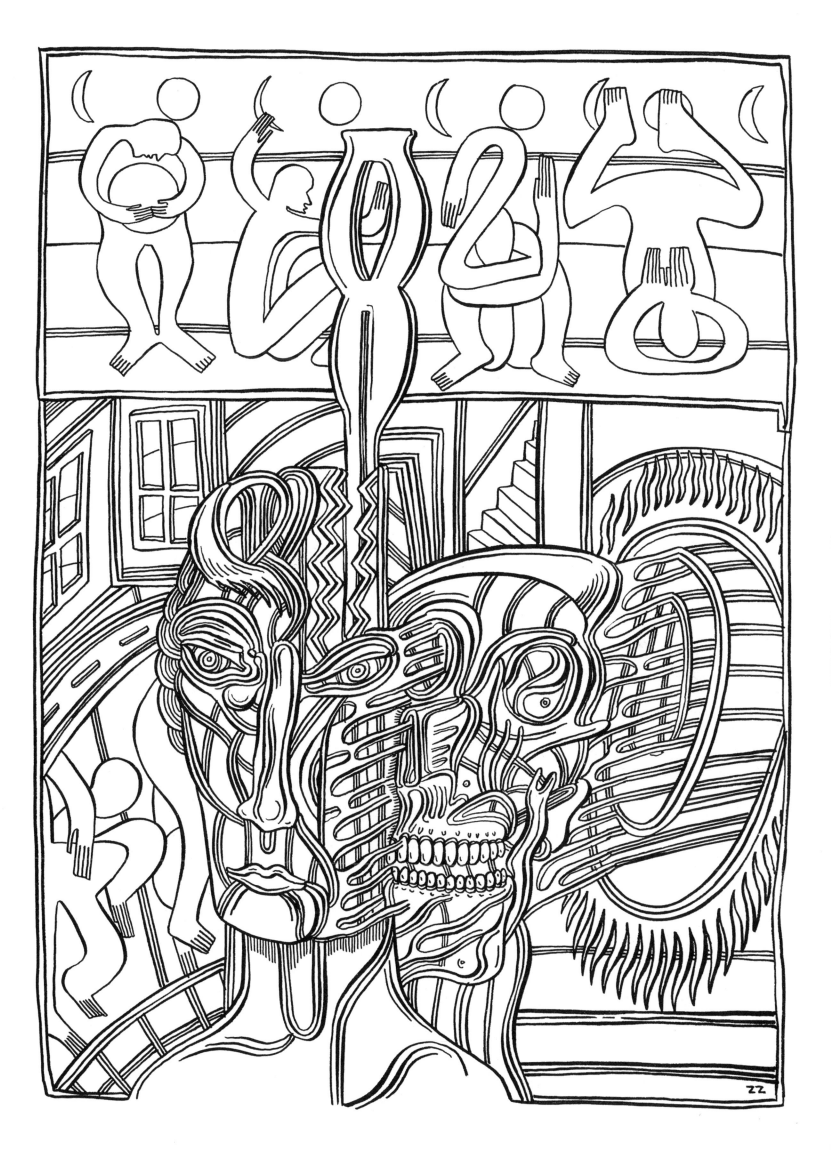

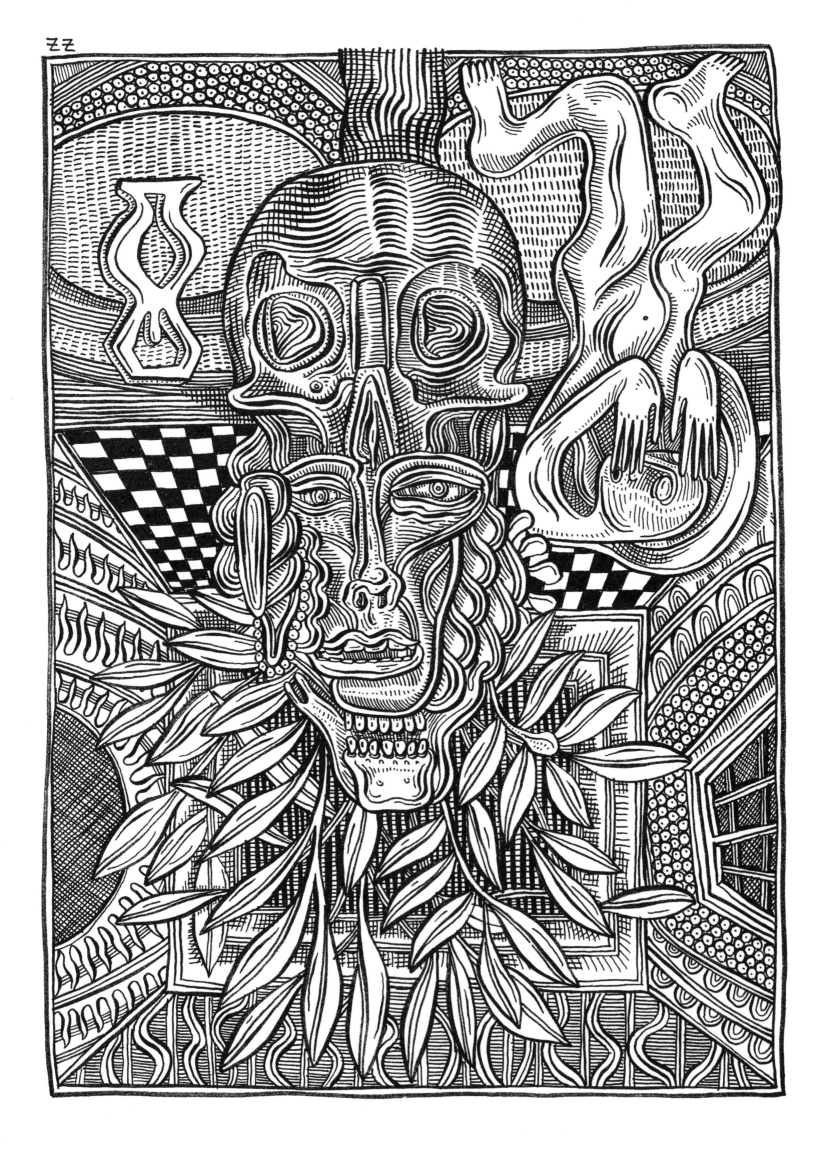

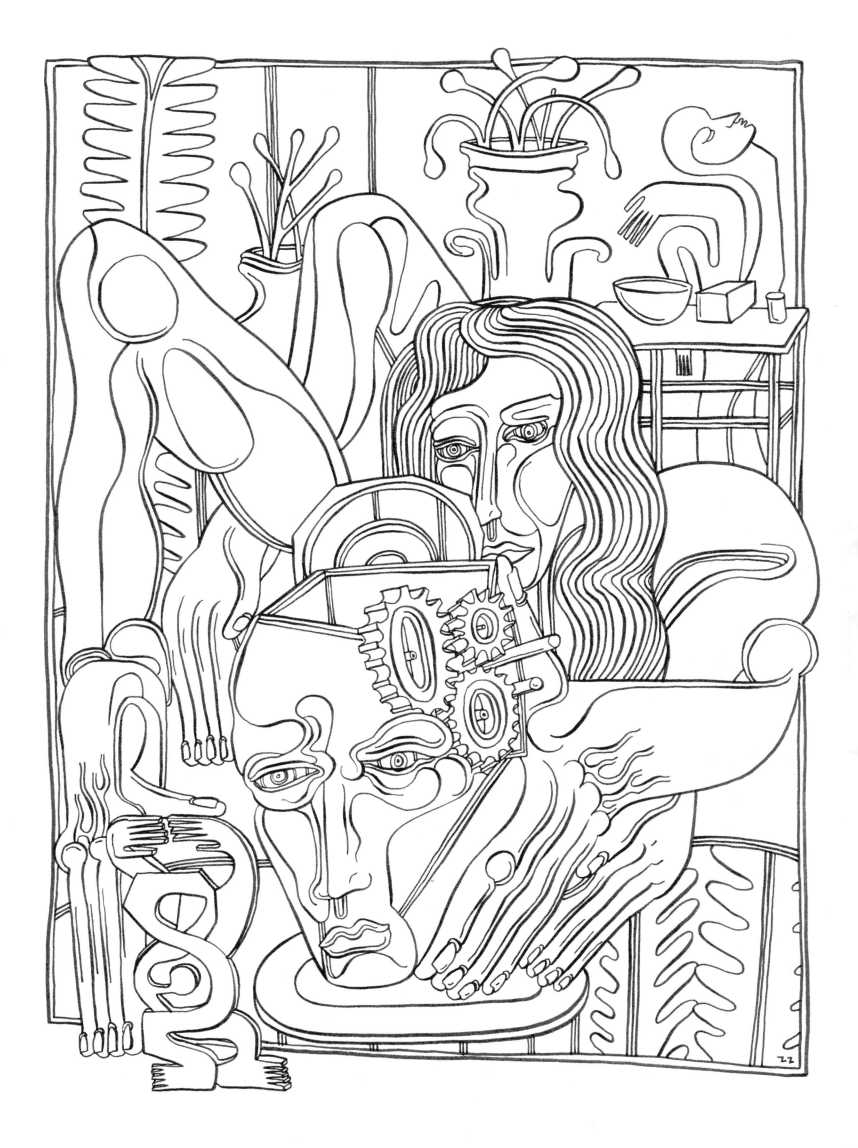

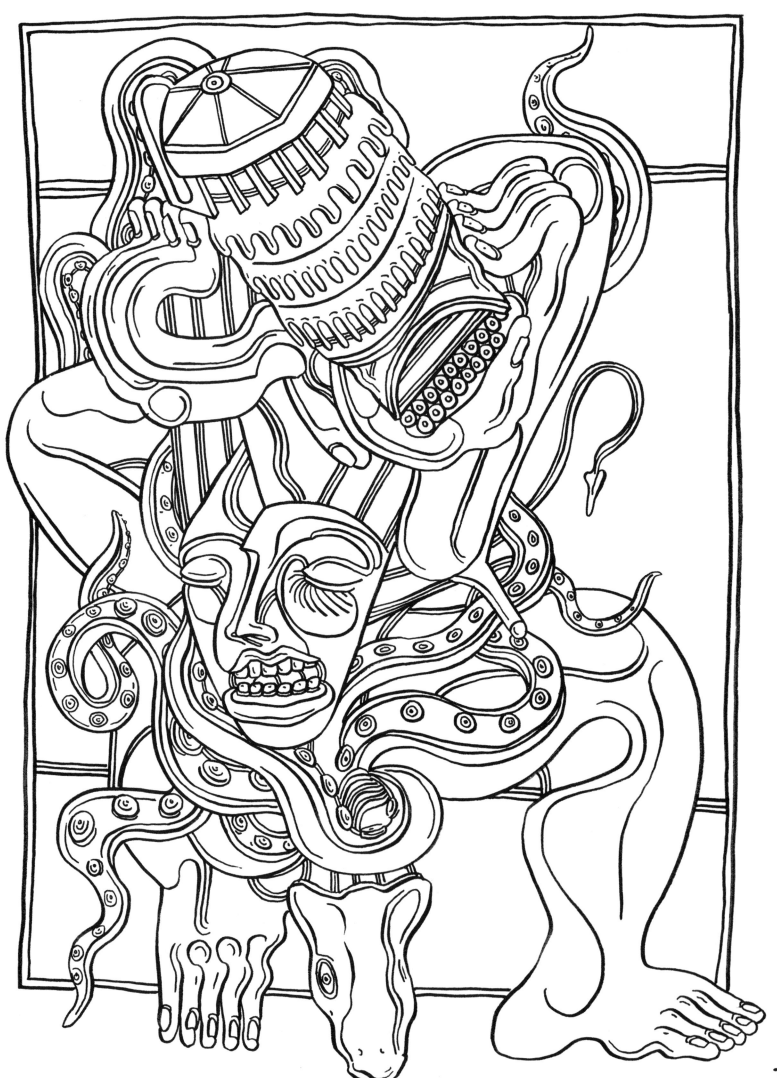

zz

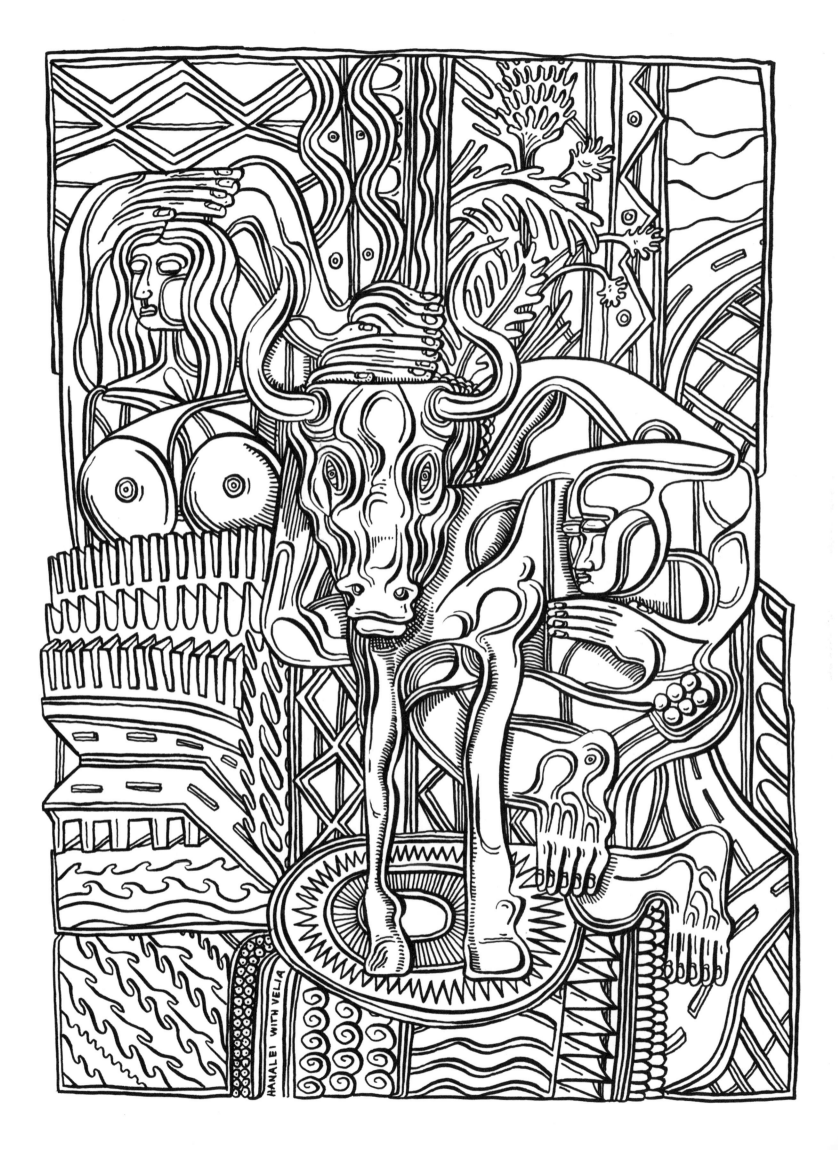

HANALEI WITH VELIA

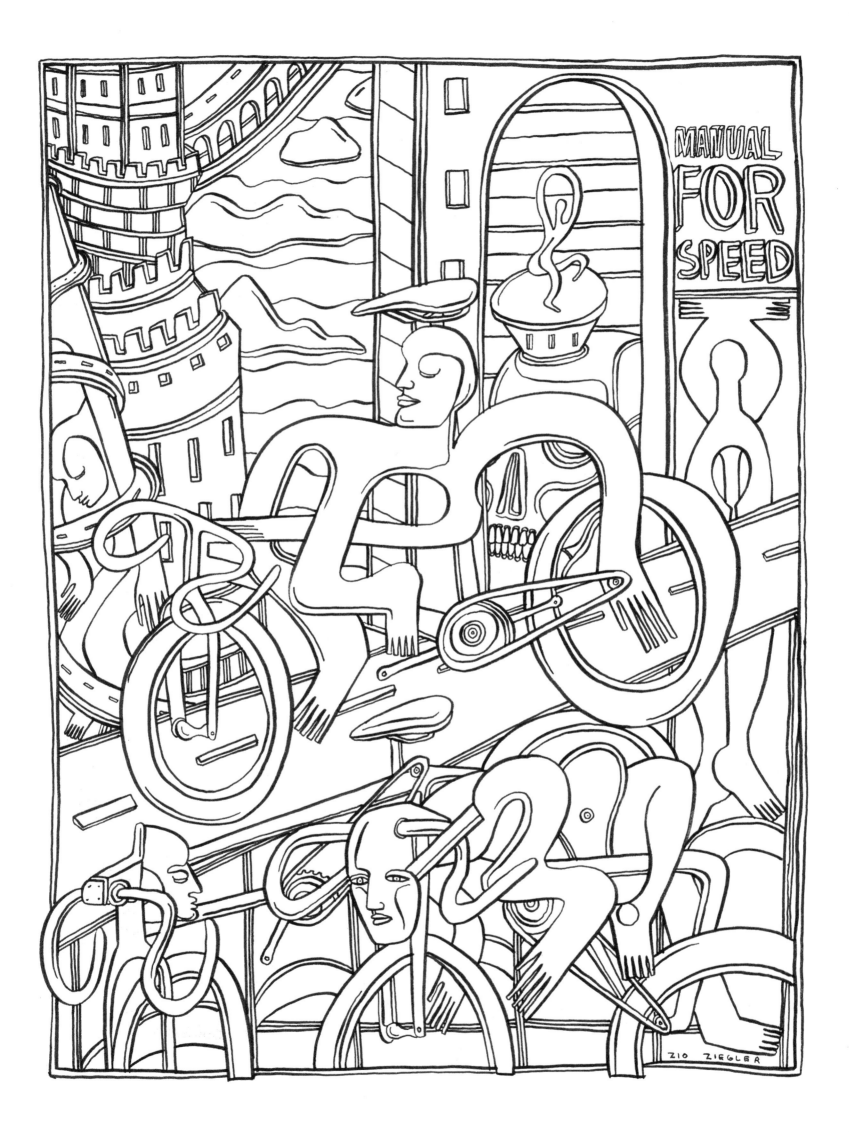

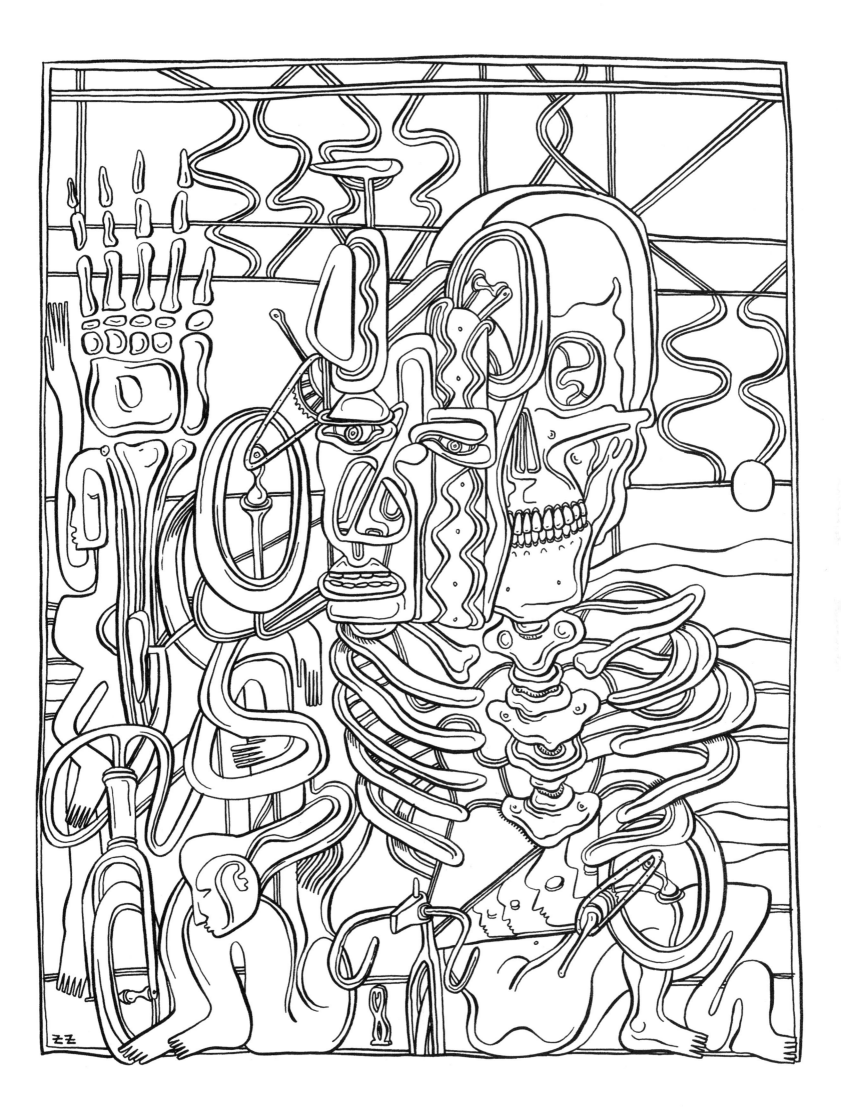

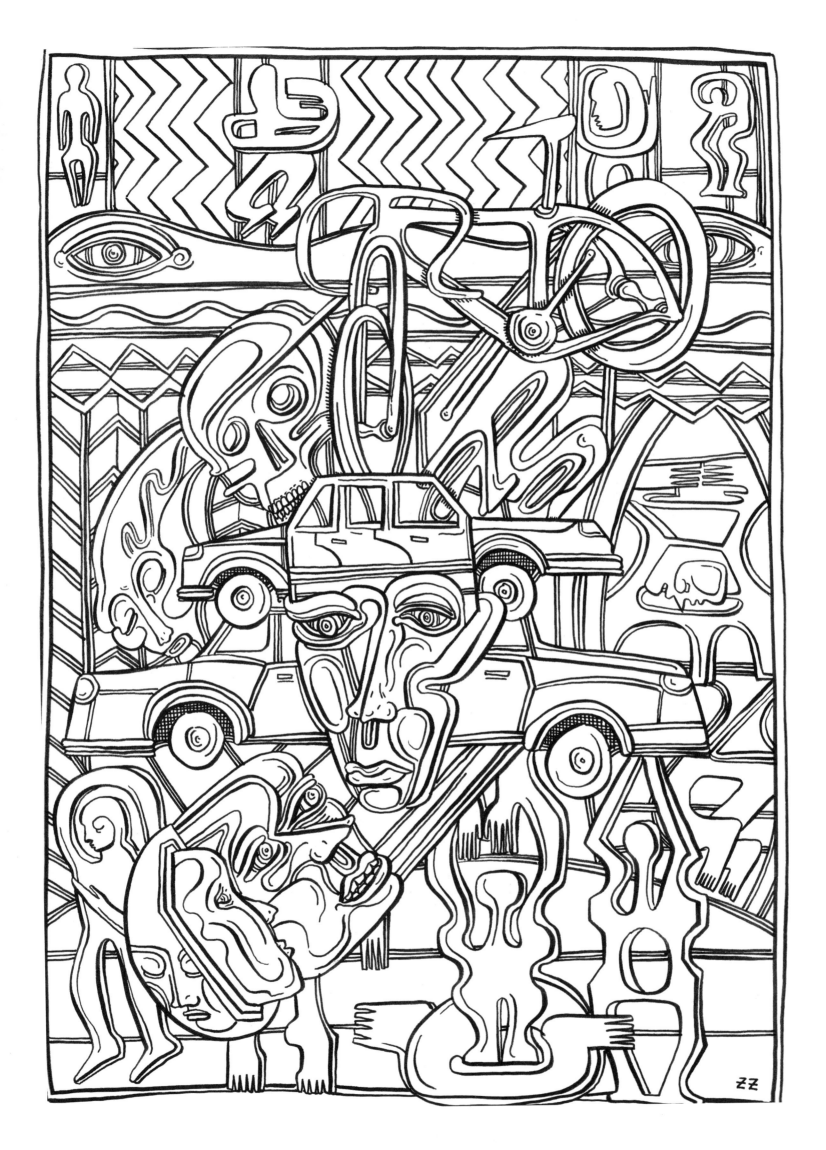

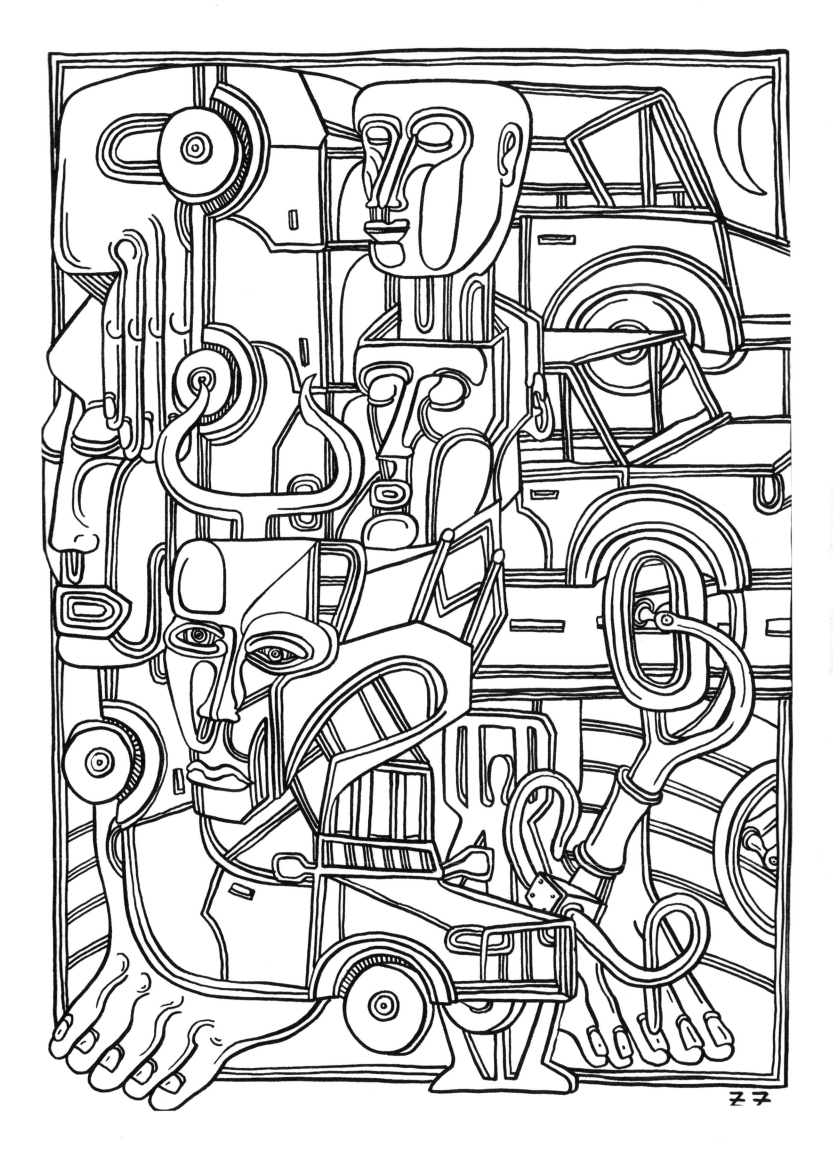

ACKNOWLEDGMENTS

Thank you to:

Melita and Mary-Katherine for showing me early on that learning could be what I wanted it to be.

Swami, Mr. Henderson, Jeff Simmons, and Harry Kisker for believing in me and getting me excited about books.

Jason Brockhert, Ian Ross, Russ Pope, Natasha Boas, Simmy Swinder, Tina Sharkey, Zem Joaquin, Molly McGettigan, James Blose, and Craig Roberts for helping me push forward regardless of the circumstances.

Bruce Katz, for teaching me how to be single-minded.

My lovely girlfriend, Velia, for completing me entirely and filling my life with endless love.

Some of my ridiculous friends—Peter, Dylan, Rik, David, Tony, Alec, Nico, Cody, James, Devin, Austin, Simon, Joe Stricker MD, Skyler, Bryce, and Dean—for the adventures.

Rob for being a best friend, an inspiration, and a scion of integrity.

Colombo for teaching me what business is like in Italy, and for the faith in what I am doing.

The guys at Proof Lab for making it all possible from sixth grade onward.

Aza, for being herself.

And my parents for loving me so entirely, being there for me through all, living by their own rules in this world, and letting me do the same.

HarperCollins books may be purchased for educational, business,
or sales promotional use. For information please e-mail the
Special Markets Department at SPsales@harpercollins.com.

Published in 2016 by
Harper Design
An Imprint of HarperCollins*Publishers*
195 Broadway
New York, NY 10007
Tel: (212) 207-7000
Fax: (855) 746-6023
harperdesign@harpercollins.com
www.hc.com

Distributed throughout the world by
HarperCollins*Publishers*
195 Broadway
New York, NY 10007

ISBN 978-0-06-244686-2
Library of Congress Control Number 2016933066

Printed in China
First Printing, 2016

ABOUT THE AUTHOR

Zio Ziegler (born February 18, 1988) is an American artist known for his intricately patterned paintings and his large-scale murals, which can be seen in major cities in the United States, Europe, and Asia. His work reflects the diverse influences of late medieval and quattrocento painting; aboriginal, African, and native art; and the European graffiti movement. Driven by intuition and depicted with a playful use of space and materials, his subject matter reflects the human condition, with references to allegorical, mythical, and artistic lineage. He paints in the belief that his paintings complete themselves by triggering self-discovery in their viewers. Zio Ziegler studied at the Rhode Island School of Design and Brown University. Since graduating with a BFA from RISD in 2010, Ziegler has developed an international studio and mural practice to support his philosophy that art should be available to all. He lives and works in San Francisco.